Henna Style Mini Coloring Book

36 Beautiful hand drawn images inspired by
Traditional mehndi

By Artist
Dwyanna Stoltzfus

Copyright © 2016 by Dwyanna Stoltzfus

ALL RIGHTS RESERVED

ISBN-10:1537512331

ISBN-13:978-1537512334

This publication is for personal use only.
No part of this publication may be reproduced, stored in a retrieval
System, or transmitted in any form or by any means – electronic, mechanical, photocopy,
Or any other - without the written permission
of the artist/publisher – Dwyanna Stoltzfus.

Unauthorized reproduction of any part of this publication by any means
Is an infringement of copyright.
All artwork and images in this publication are
Protected by copyright law

Join the Fun!!
Share your colored pages!!

You are invited to color the pages

From this and all publications by

Dwyanna Stoltzfus. Then scan and post

Your colored creations in

Coloring with Dwyanna

Adult Coloring Group

On facebook

https://web.facebook.com/groups/

1519357628356169/?_rdr

Join Coloring with Dwyanna Coloring Group,

And have fun sharing your colored pages

And meeting new coloring friends.

Members of the group will also have access

To free coloring pages.

You are welcome to share your colored pages on

Any social network, make sure to mention

the title of

The book and the author/artist name.

Uncolored images may not be shared.

Check out my blog at:

coloringwithdwyanna.blogspot.com7

PDF Printable coloring pages available

On Etsy at

https://www.etsy.com/people/dwyannastoltzfus

Follow Dwyanna's art on facebook at

Oodles of Doodles Designs –

Adult Coloring Books by

Dwyanna Stoltzfus

https://web.facebook.com/Oodles-of-Doodles-Designs-Adult-Coloring-Books-by-Dwyanna-Stoltzfus-743502922387046/

About:

You are going to love this coloring book!!

Get ready to color 36 henna style coloring pages by Artist Dwyanna Stoltzfus.

The beautiful designs in this book were inspired by traditional mehndi patterns.

This coloring book will provide many hours of entertainment.

It will also provide hours of peaceful calm and relaxation. Coloring is not just for children.

We encourage our precious children to draw and color as a relaxing quiet activity.

Coloring can have the same relaxing/calming effect on adults.

It is especially beneficial to those who struggle with anxiety or stress.

It's the perfect stress relief.

In this adult coloring book you will find 36 beautiful illustrations, printed one per page.

A collection of henna designs inspired by the love of traditional mehndi patterns.

You will find gorgeous intricate peacocks, flowers, hearts, paisleys and

butterflies which are all at the heart of traditional henna patterns.

You can use this coloring book to help you relax and unwind or just to have fun.

You can color the illustrations simply or add depth by shading.

Crayons are not recommended for the intricate detail but can be used on some of the pages.

You can also color with fine tip markers, gel pens, and colored pencils.

Enjoy the experience of coloring!!

But most of all relax and have fun!!

Coloring tips:

If you desire to add depth to your coloring you can shade with colored pencils.

Use dark colors around edges and into the peaks. Blend in light colors for the

middle and more open spaces. You can use black to darken areas,

and white to lighten and brighten areas.

Acknowledgments

Thank You to my family for all your support
of my art and this project.
I could not have done it without you!!

Thank You God for the gift and love
Of art and drawing!!

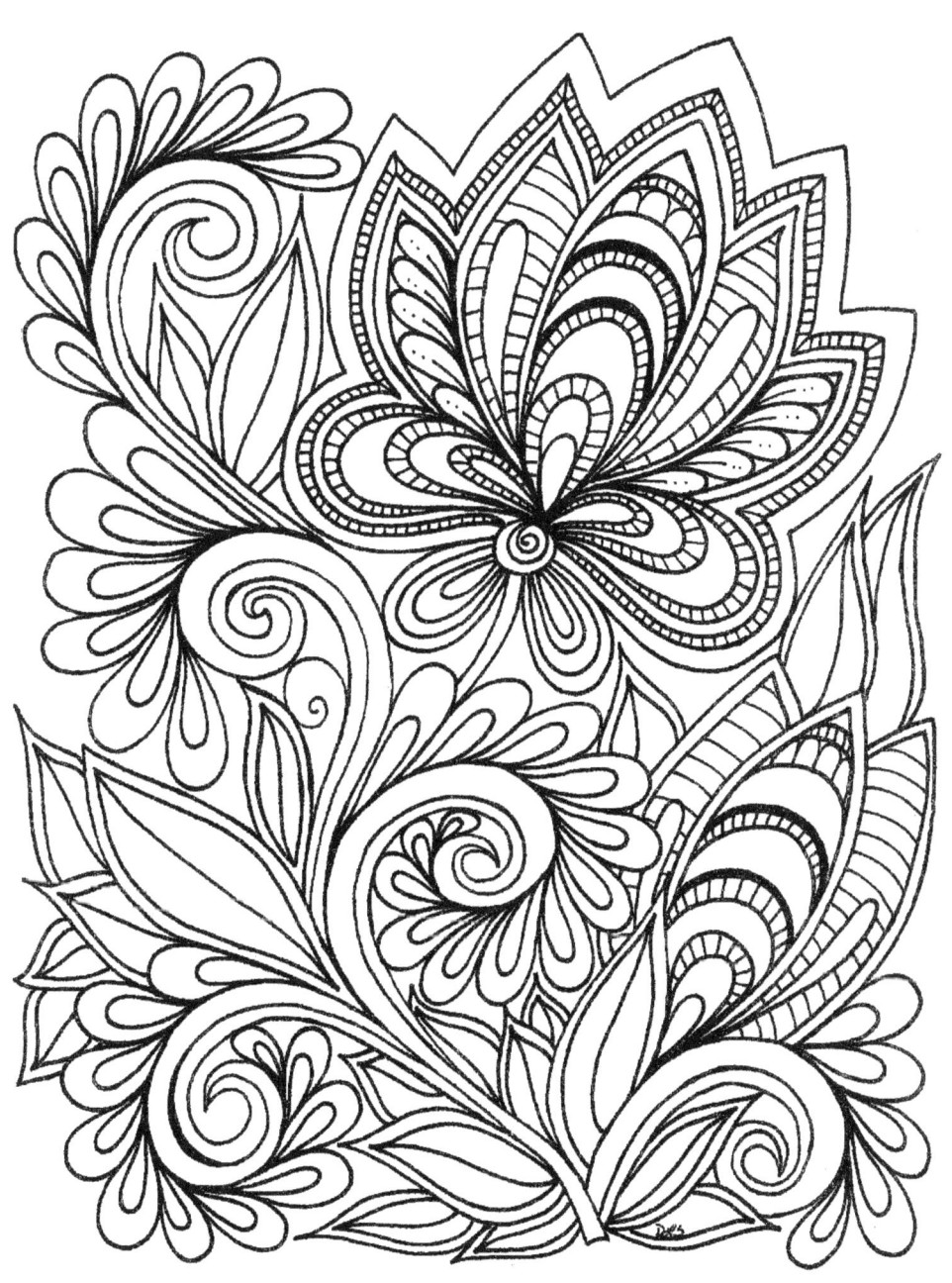

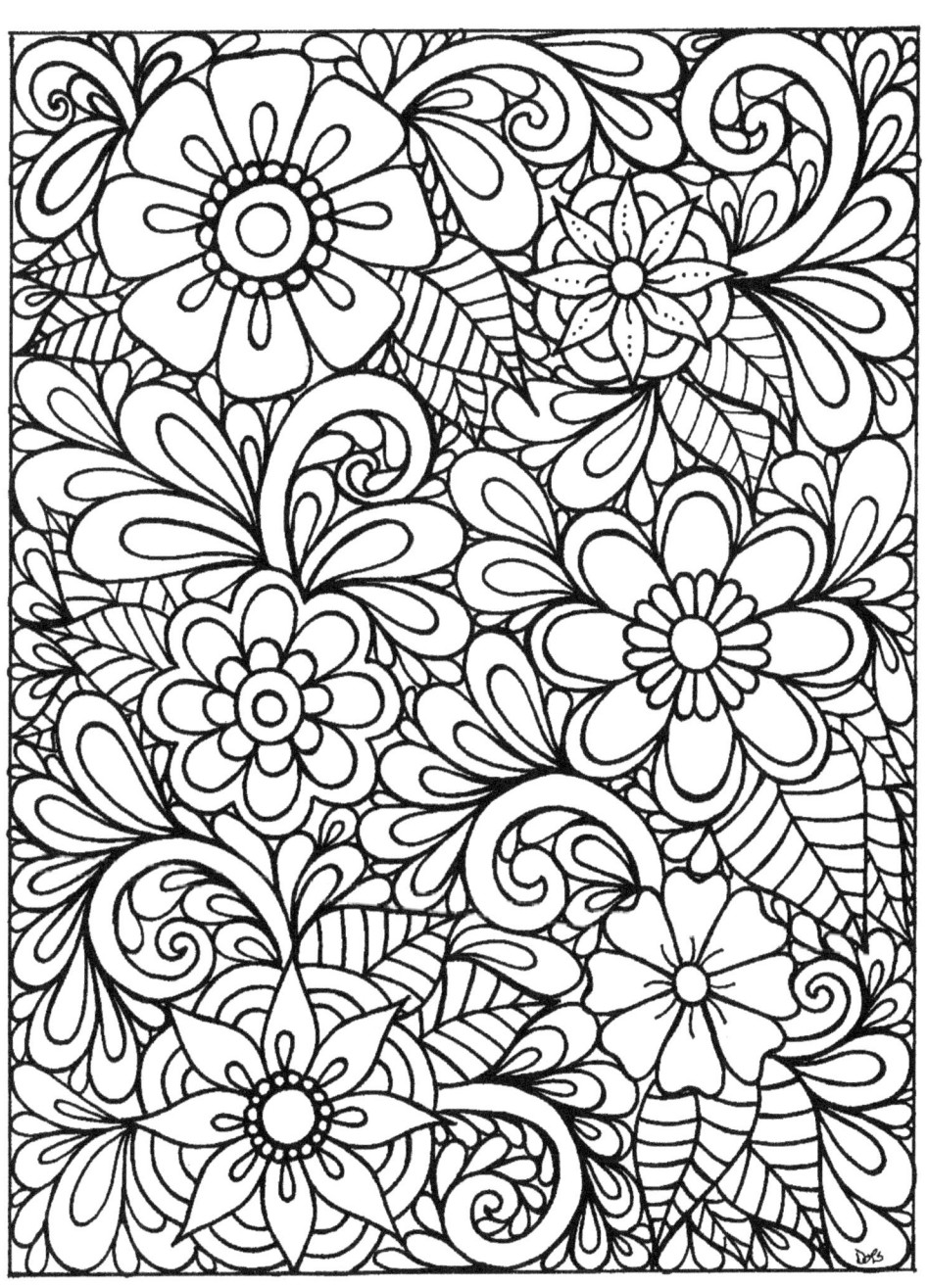

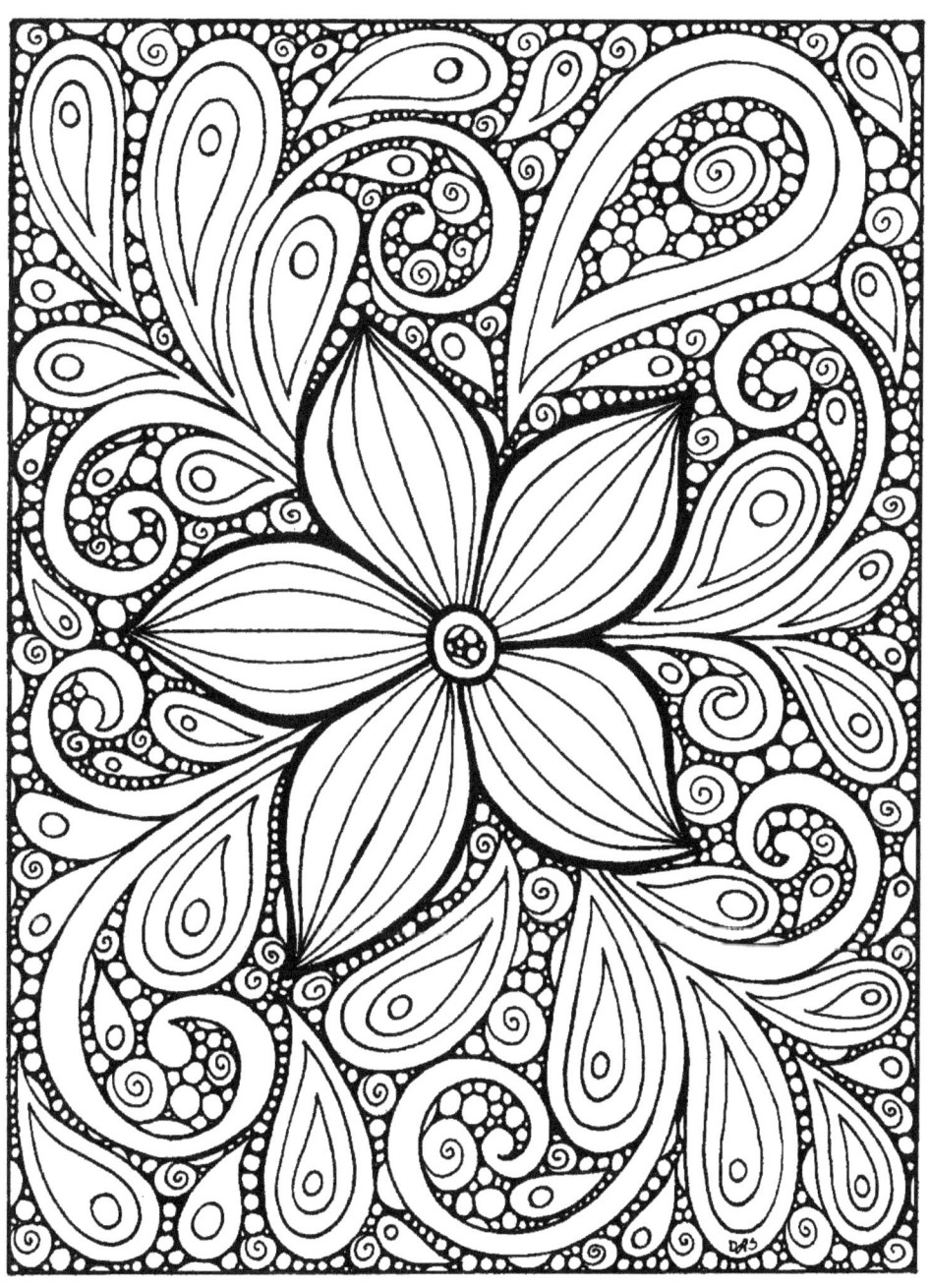

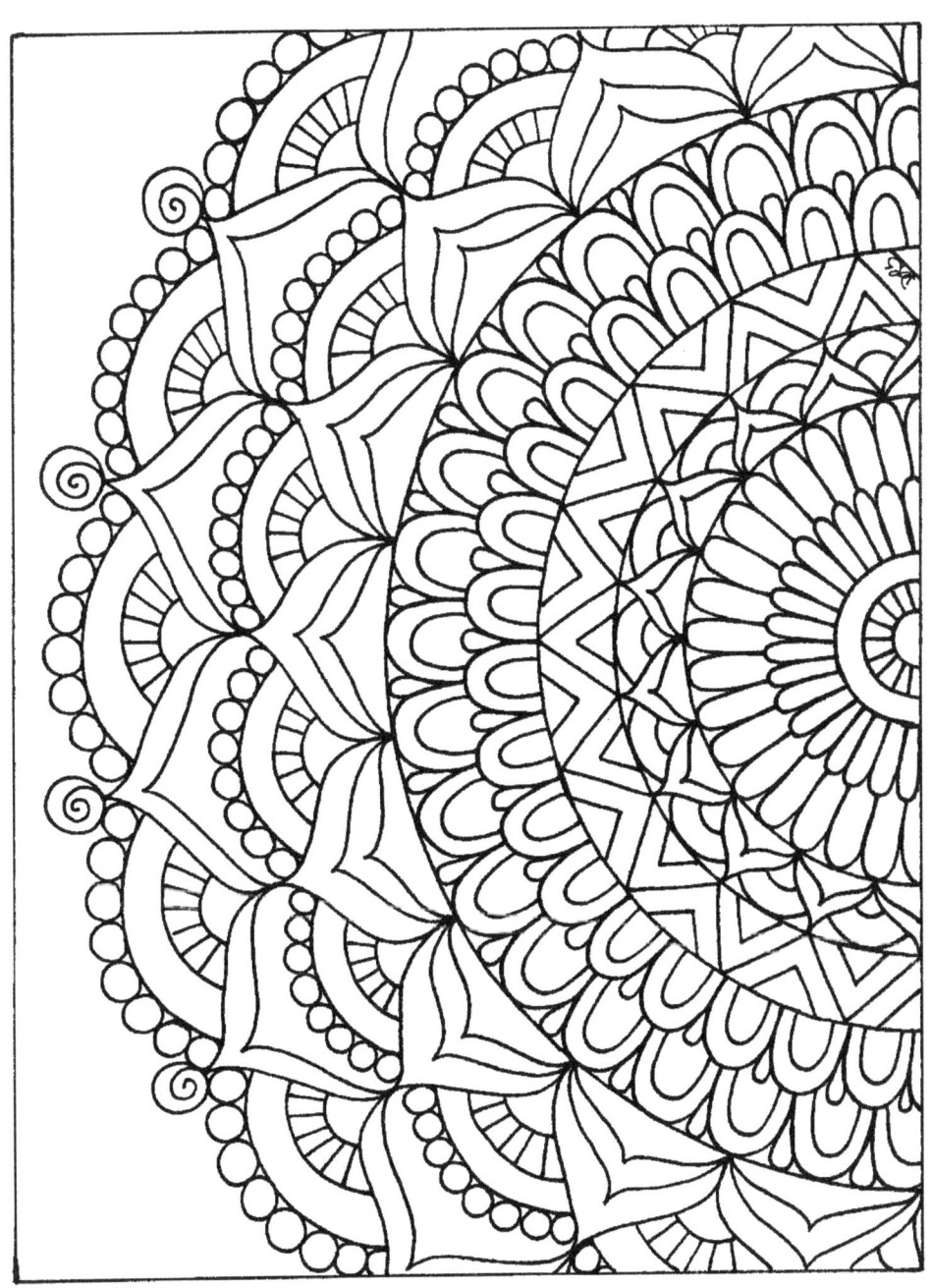

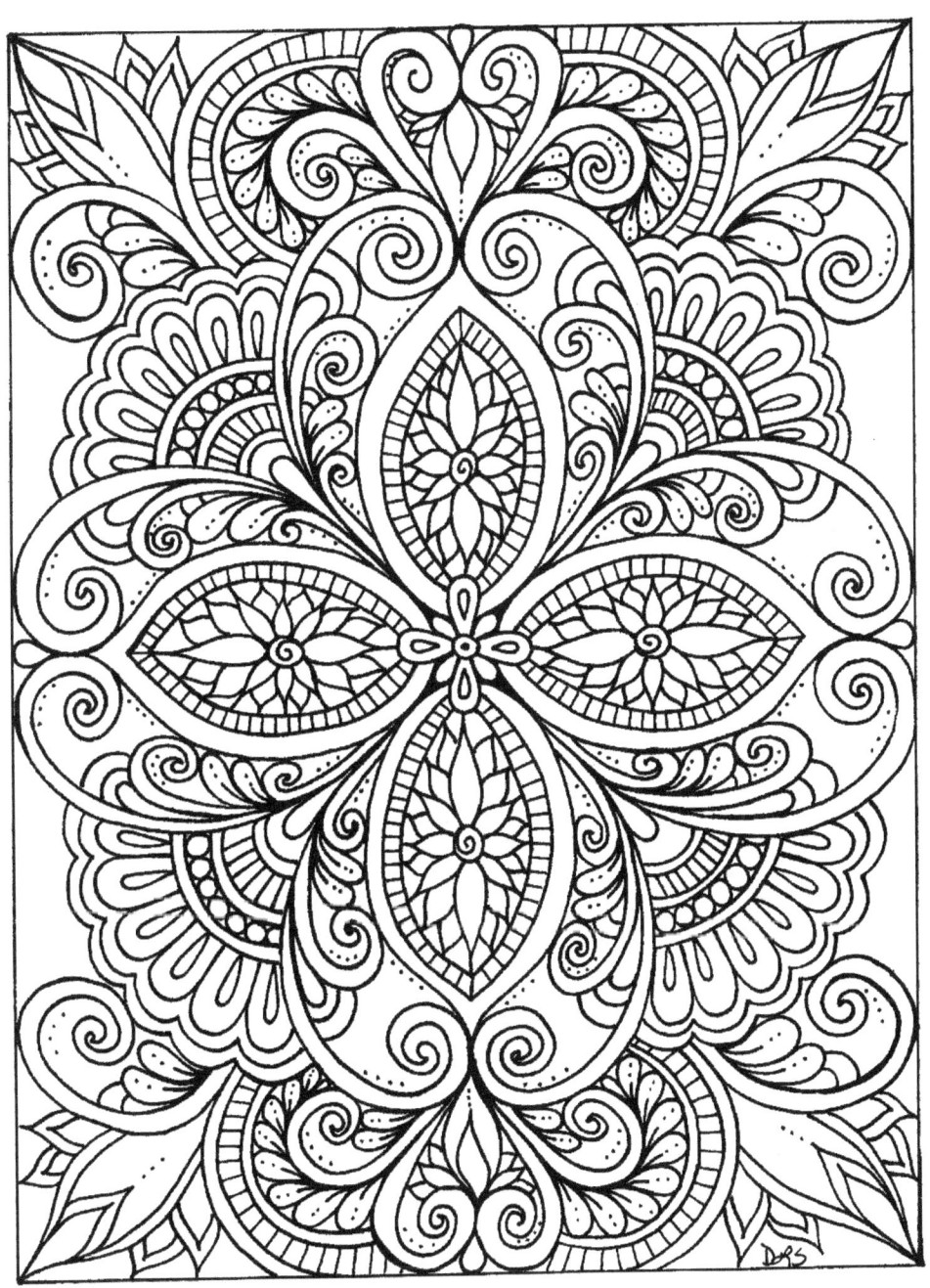

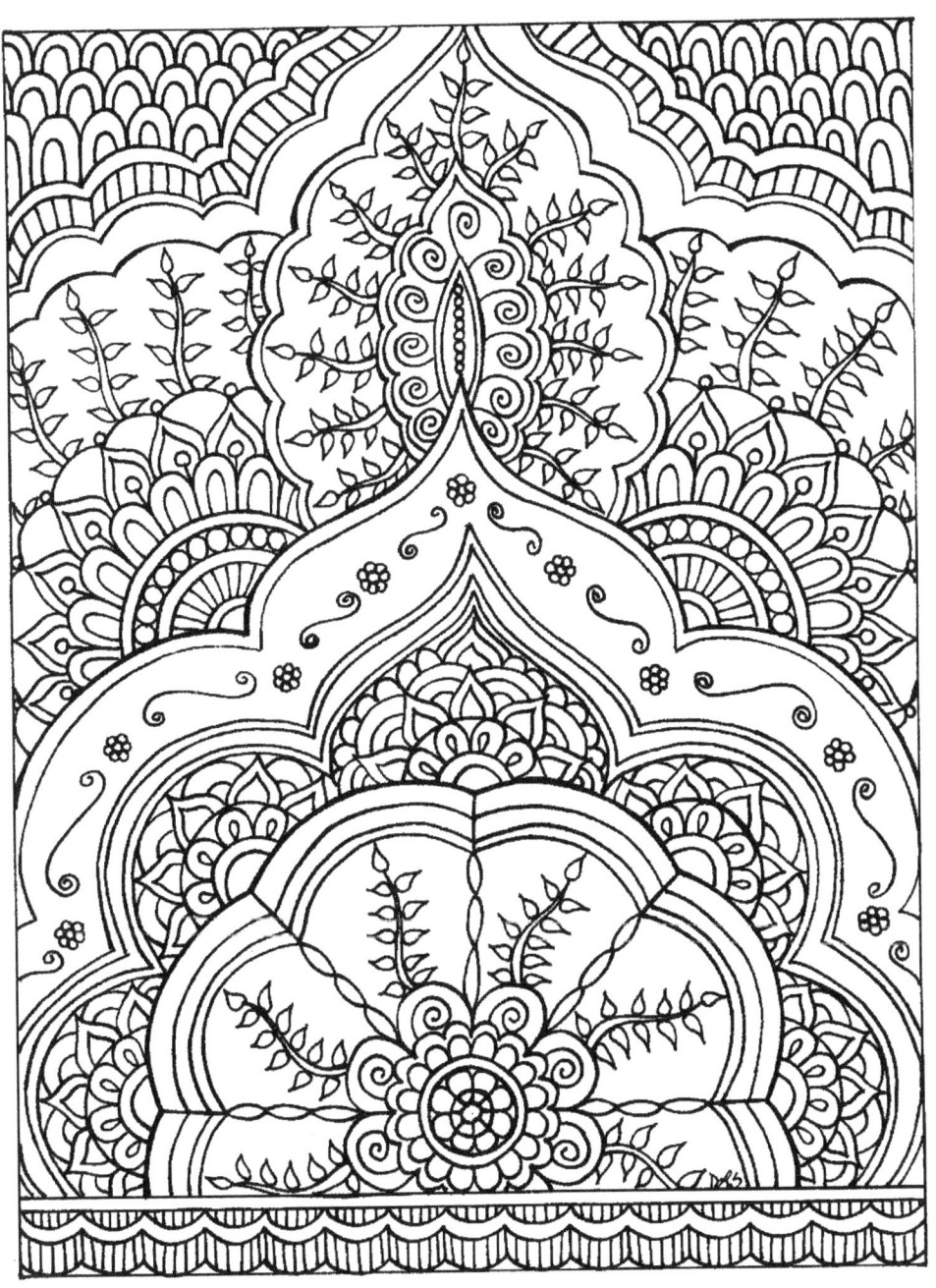

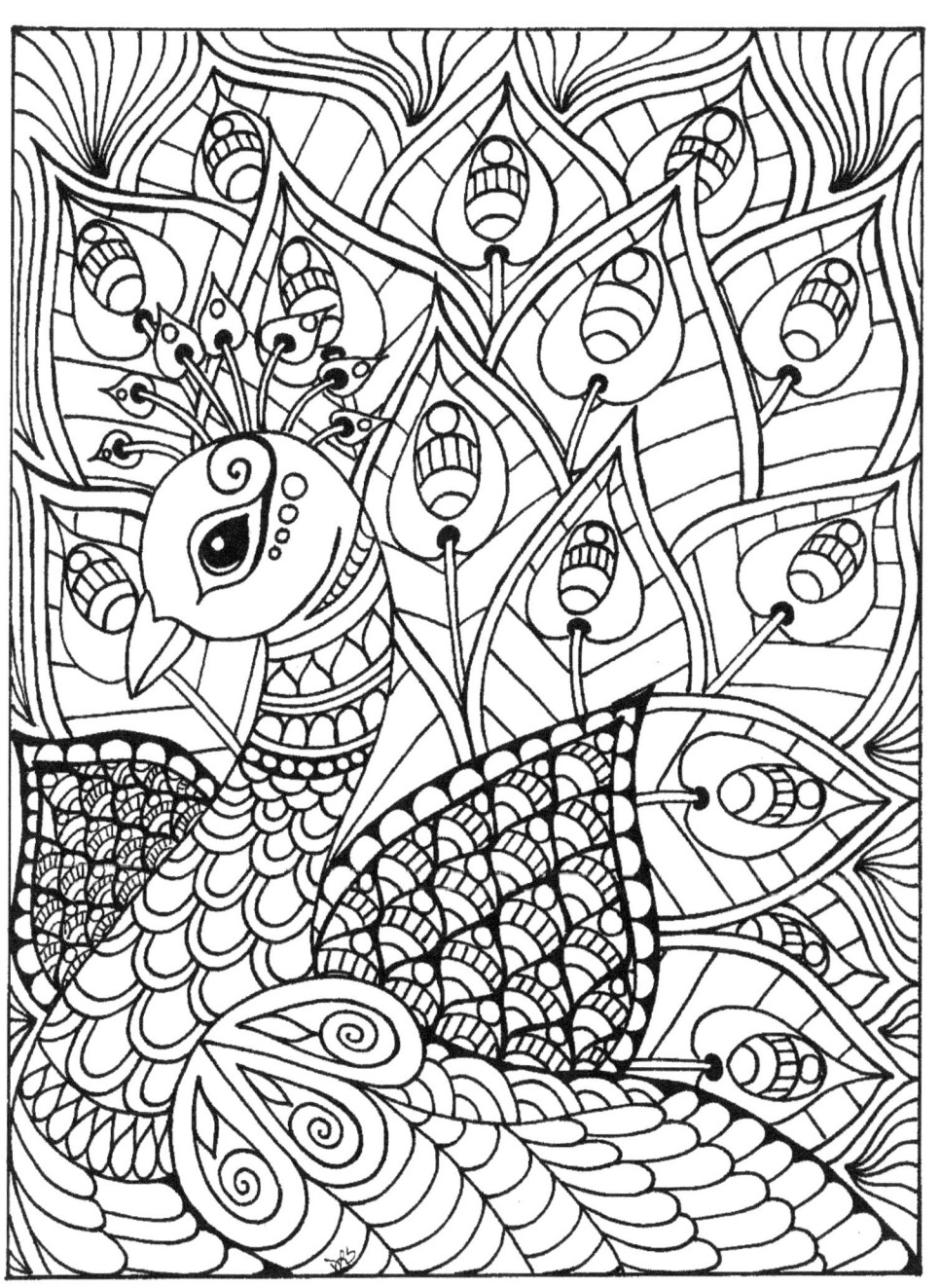

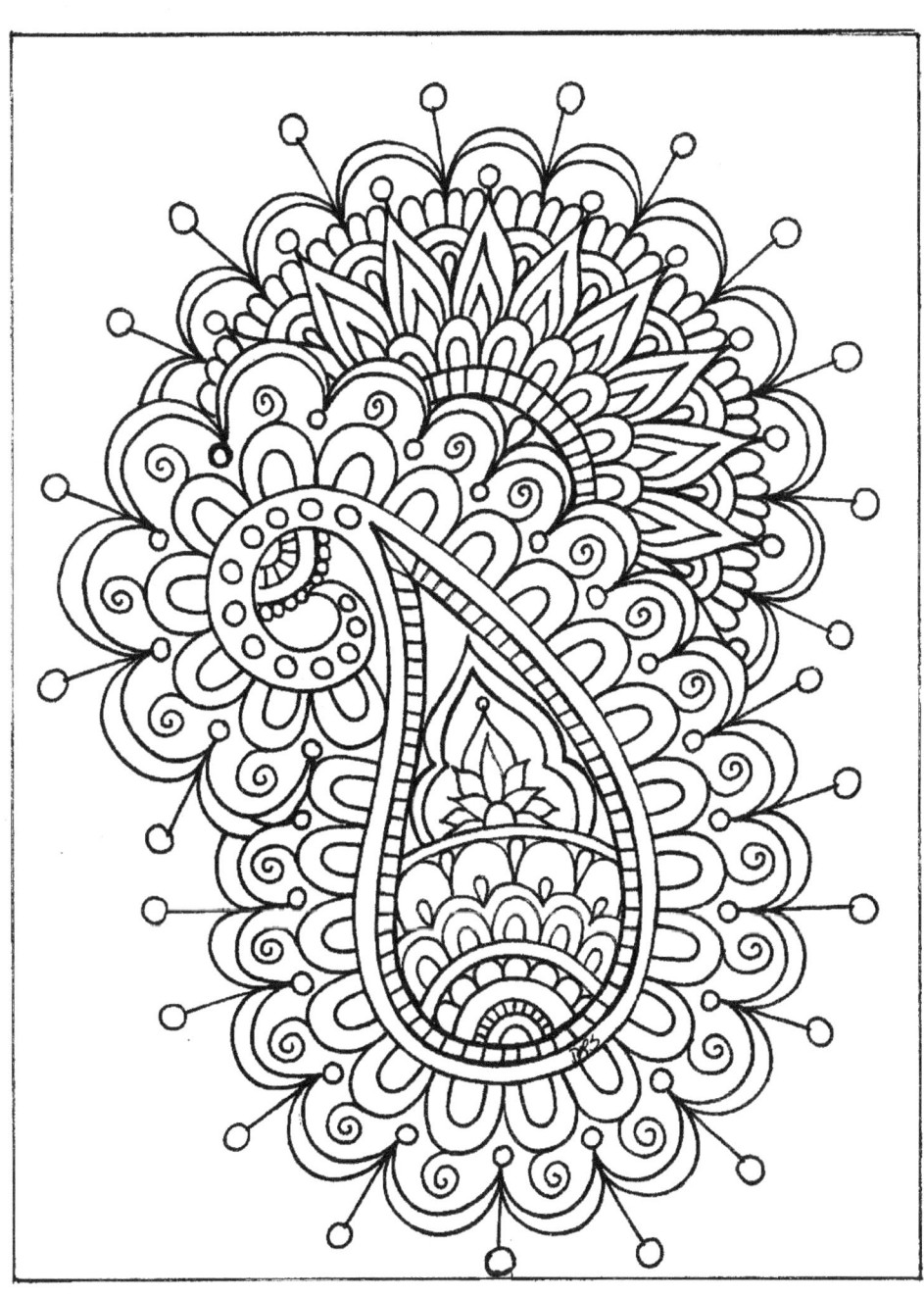

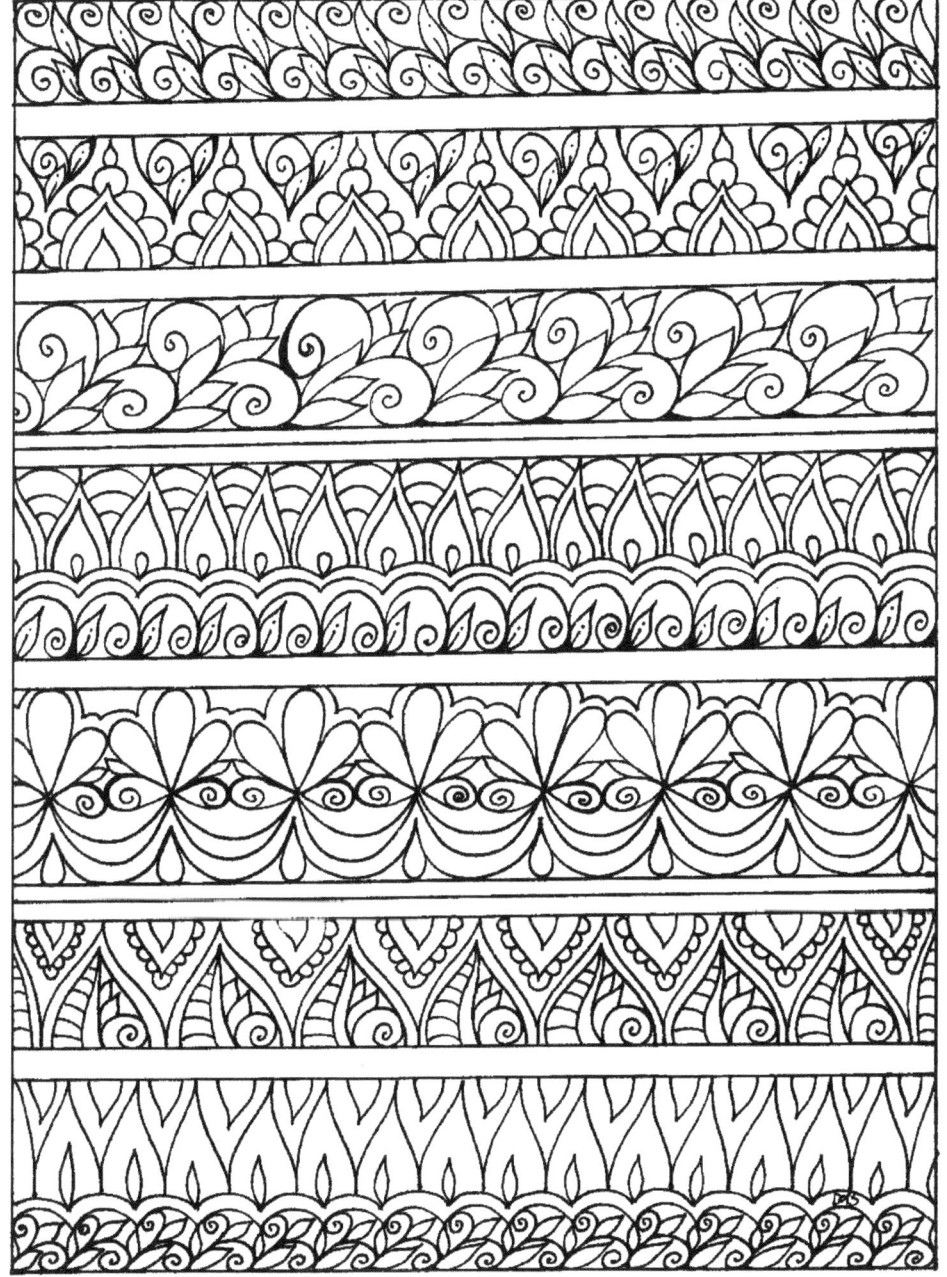

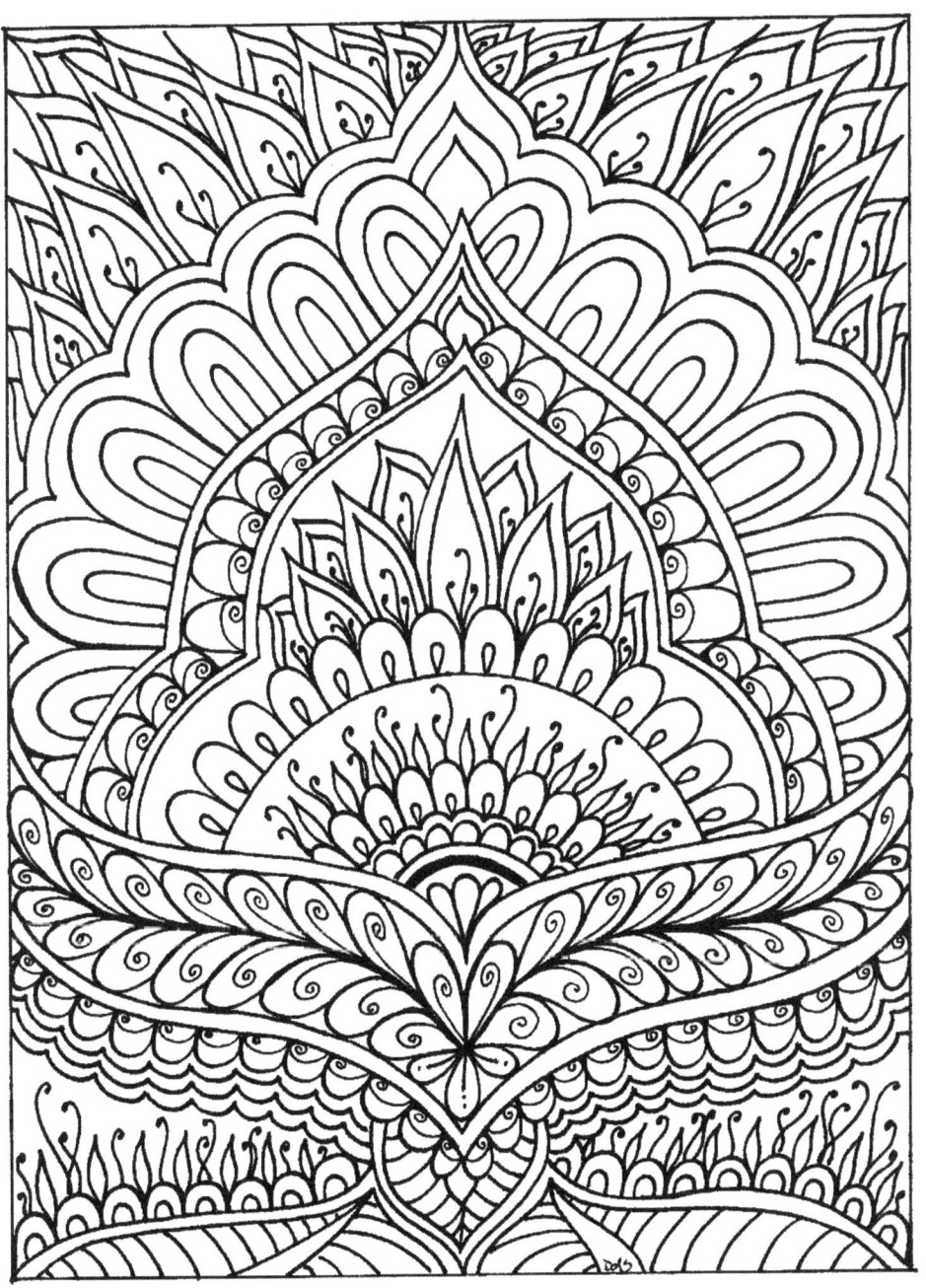

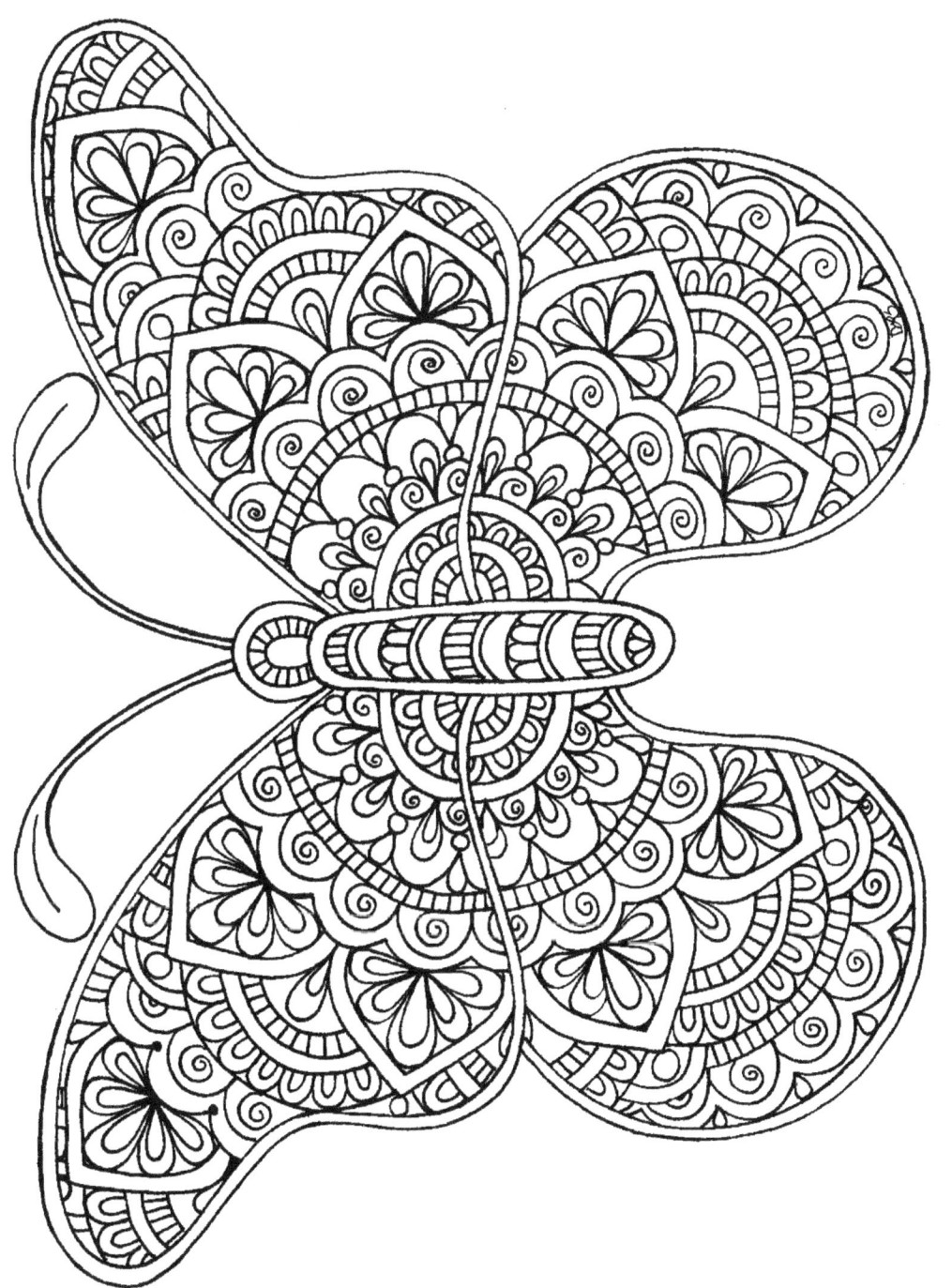

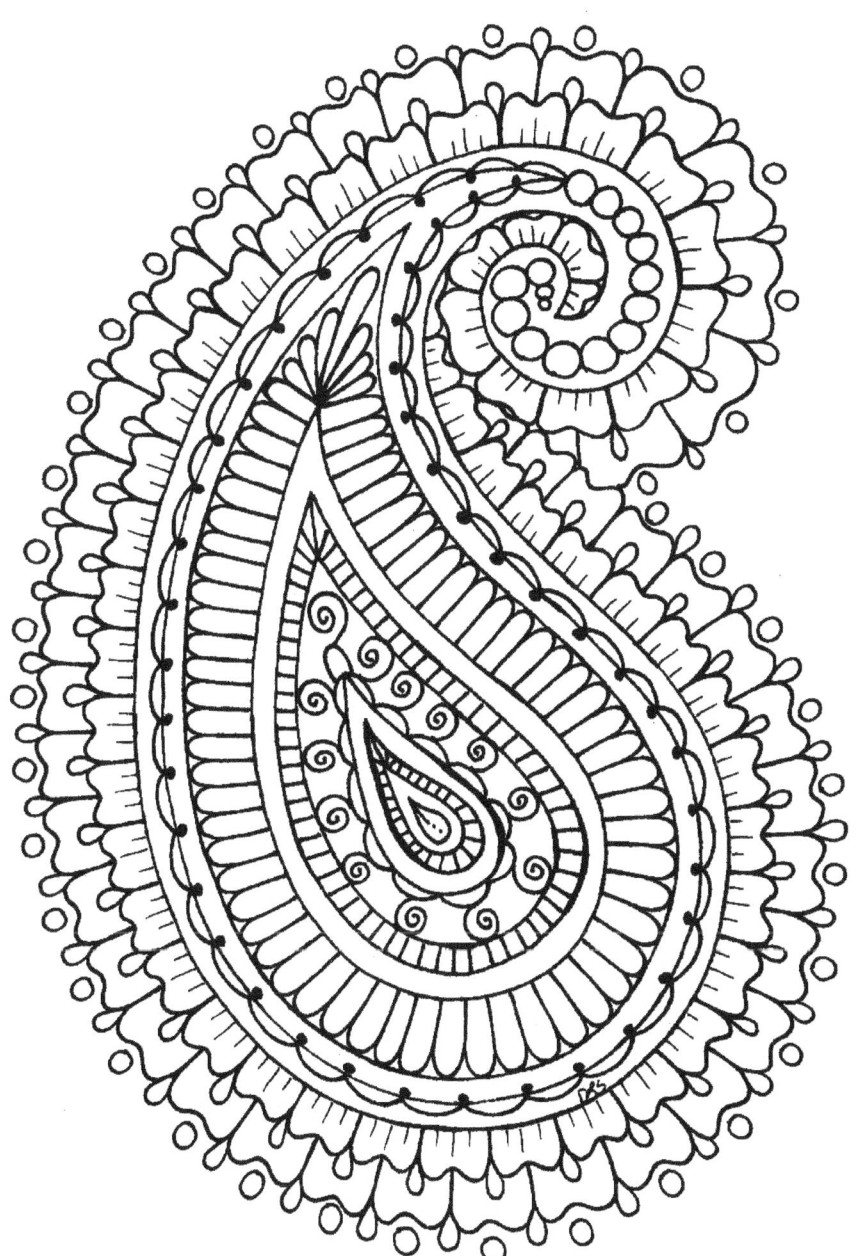

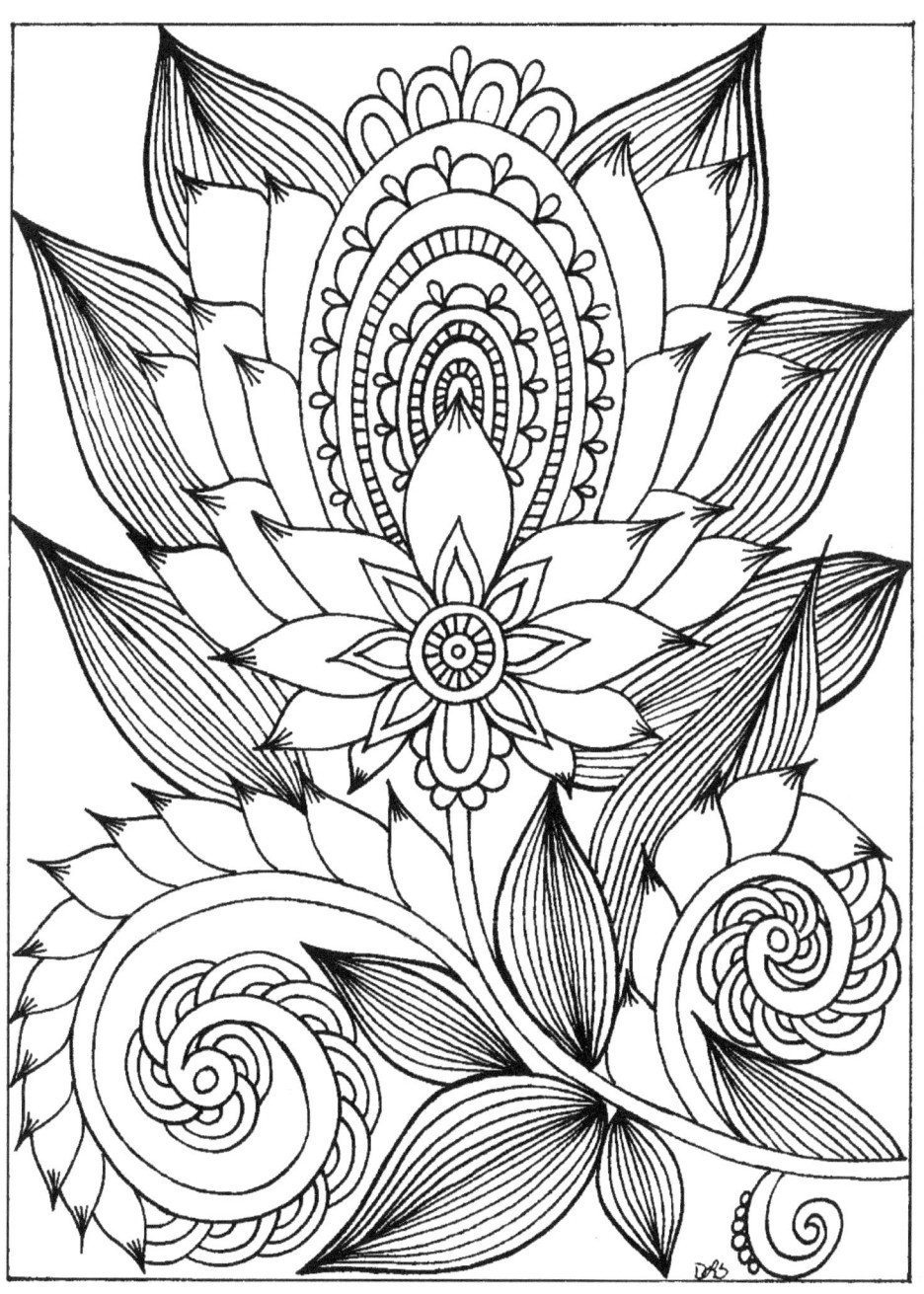

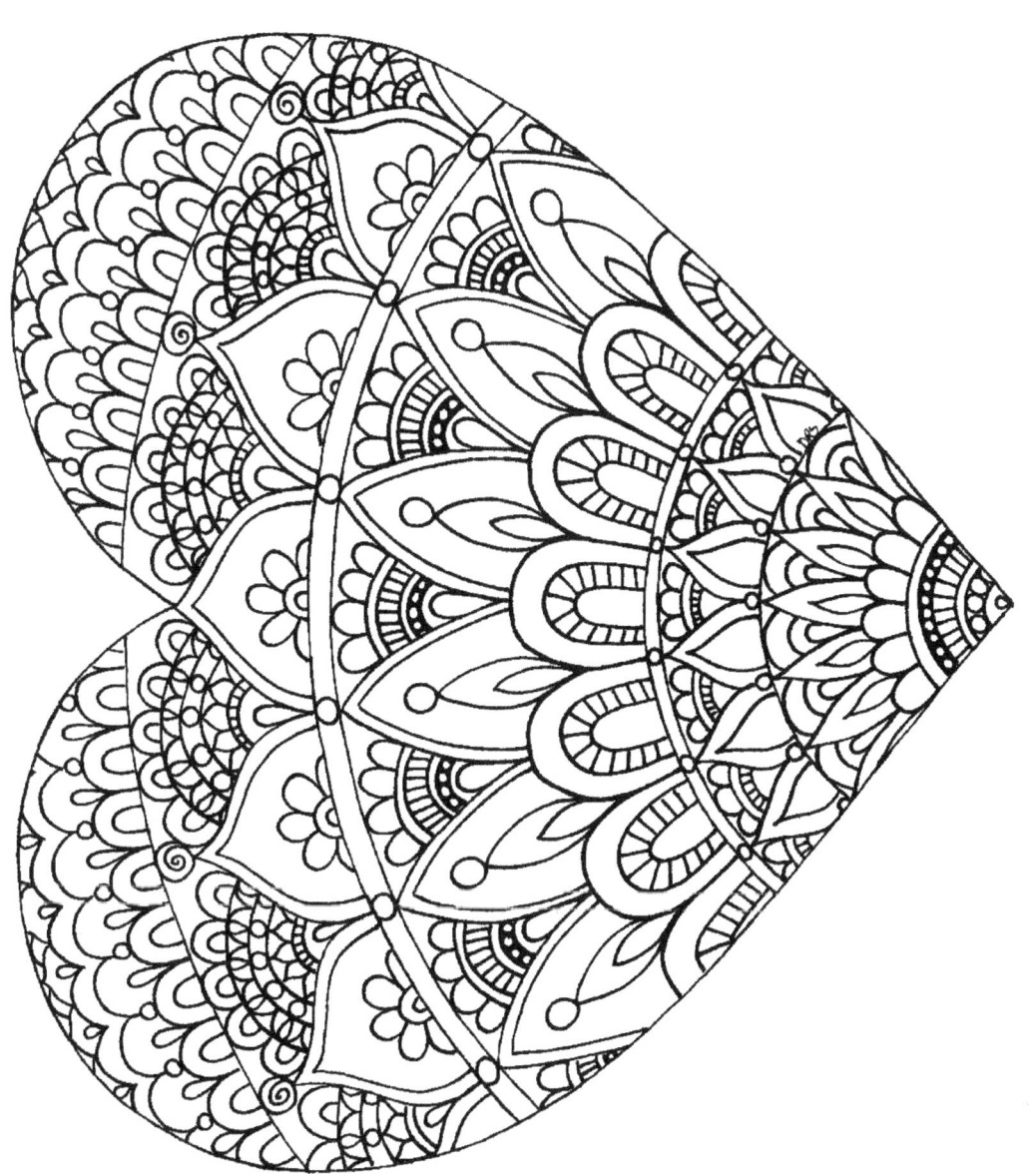

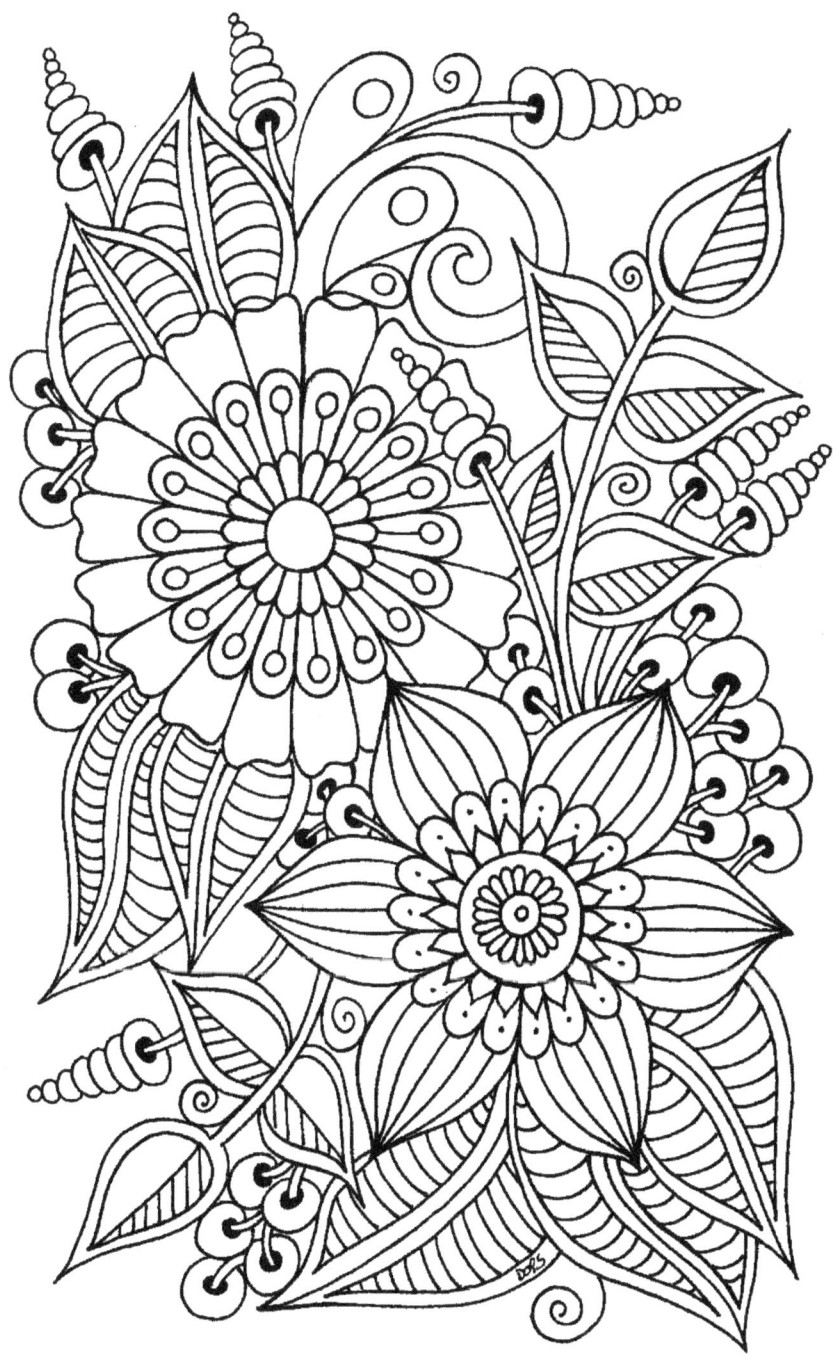

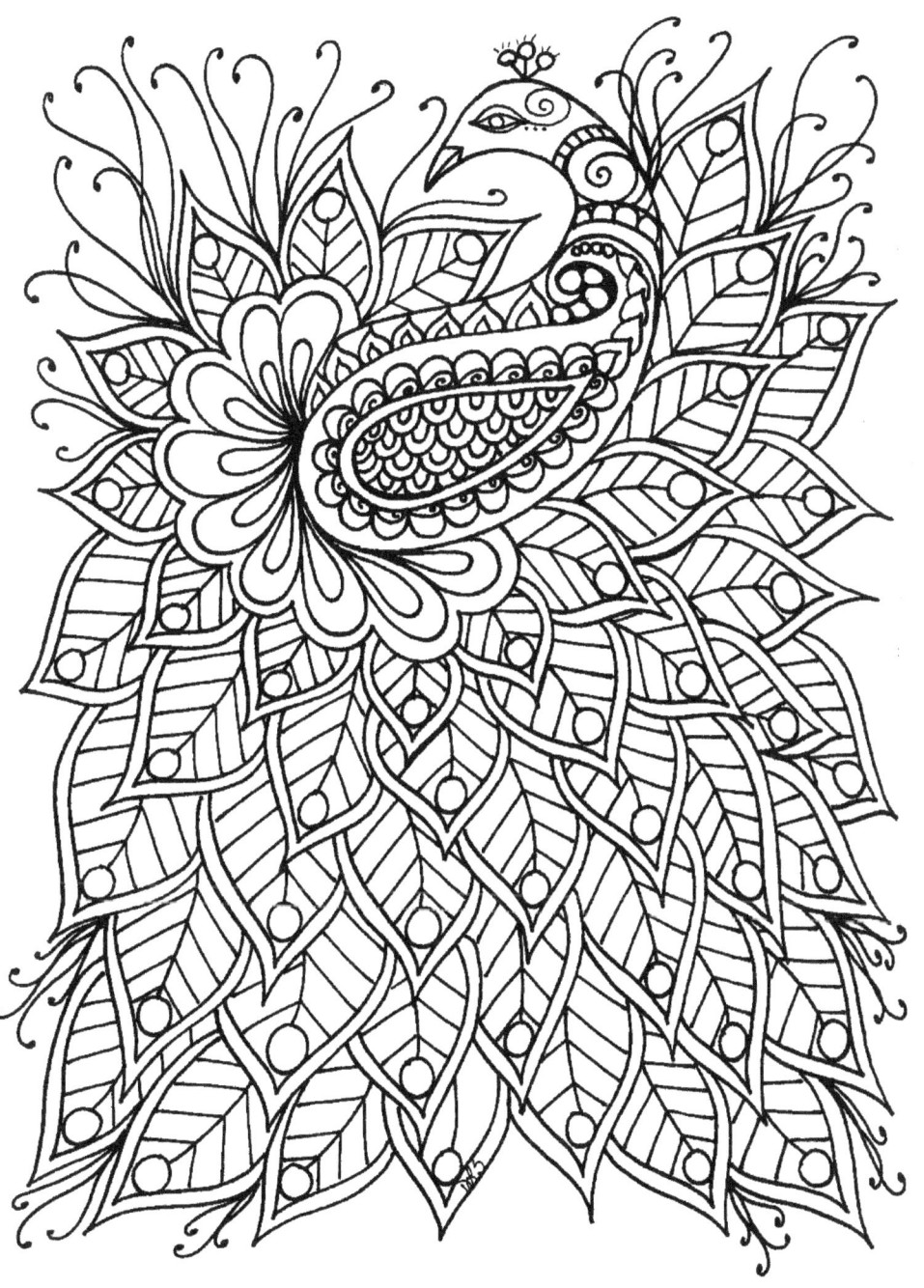

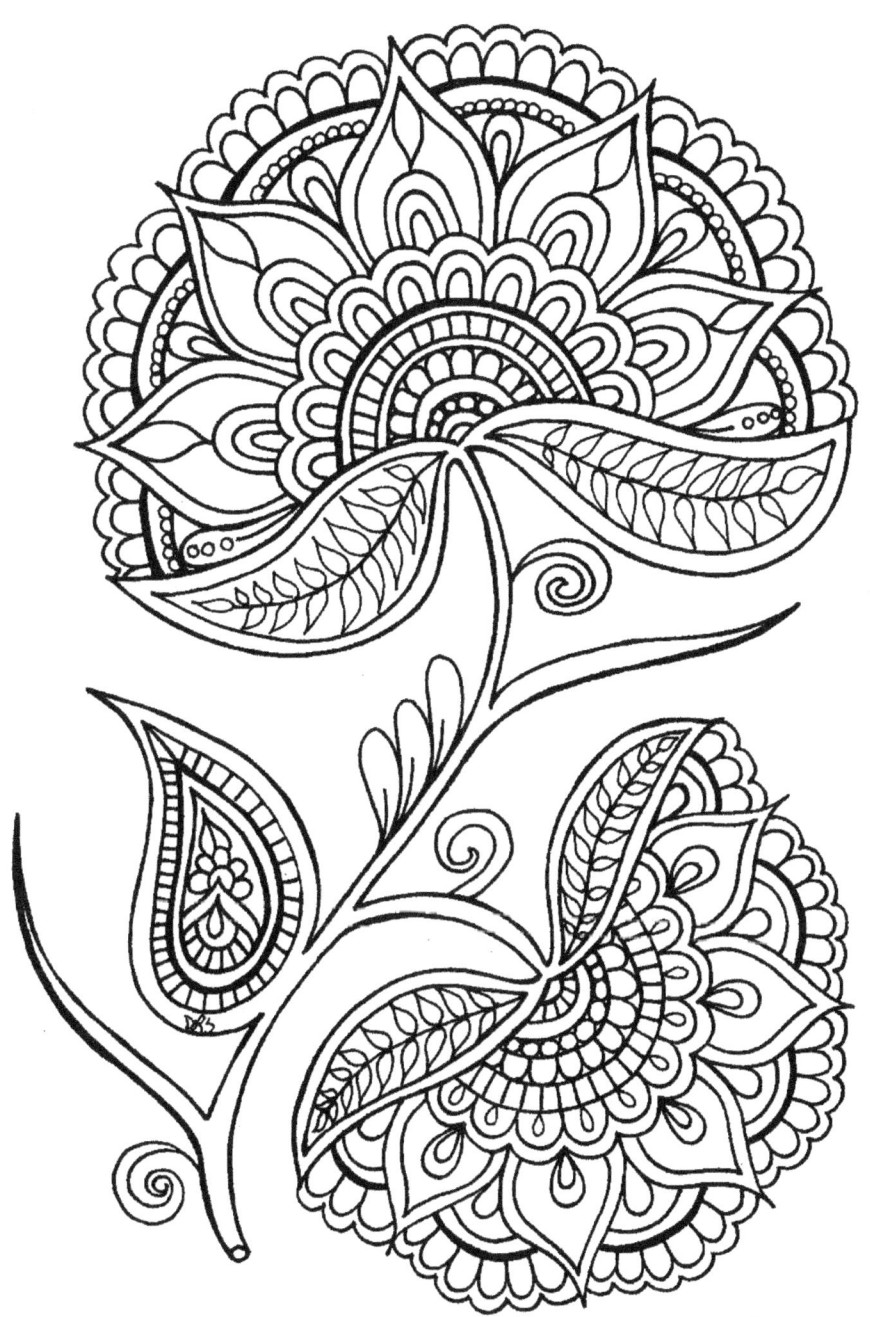

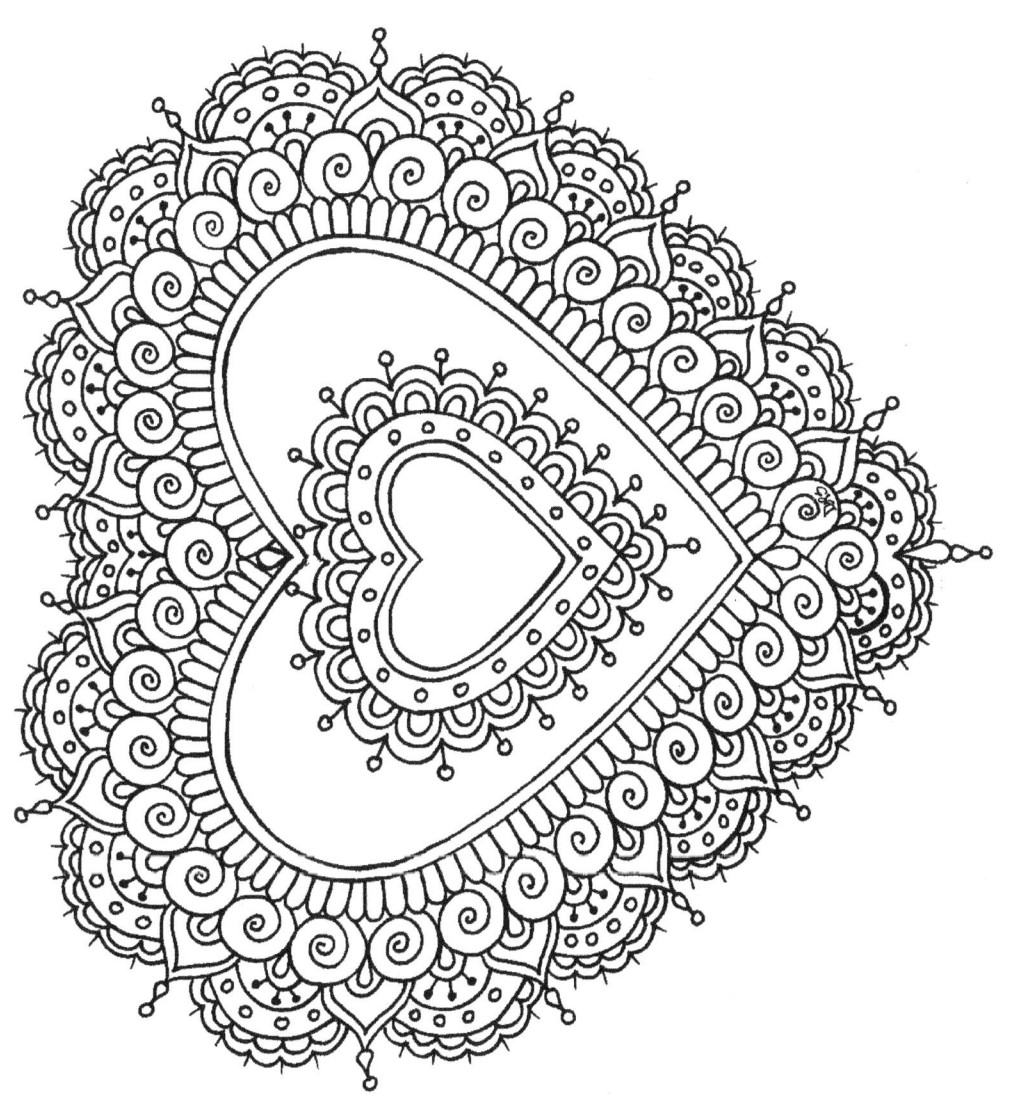

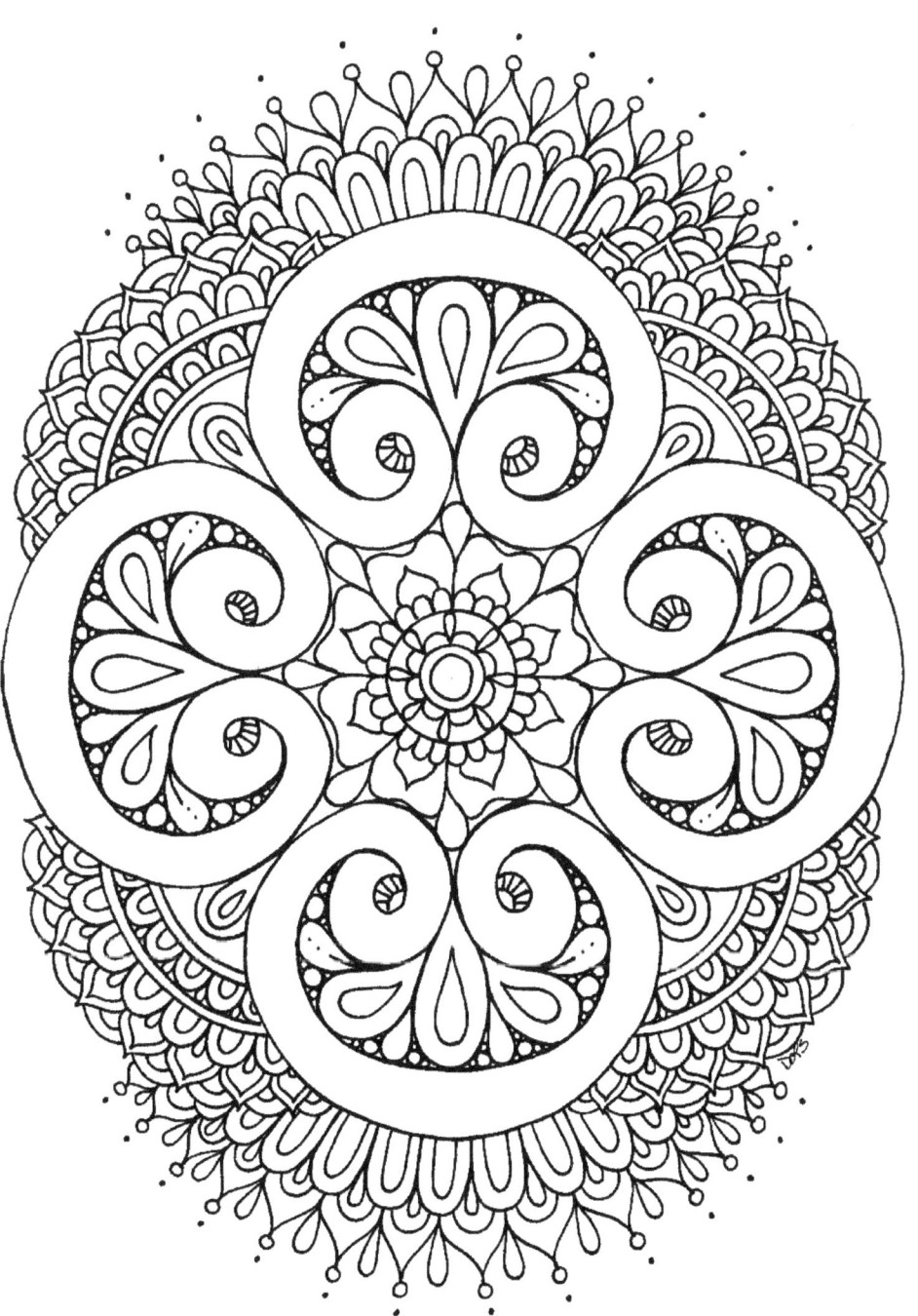

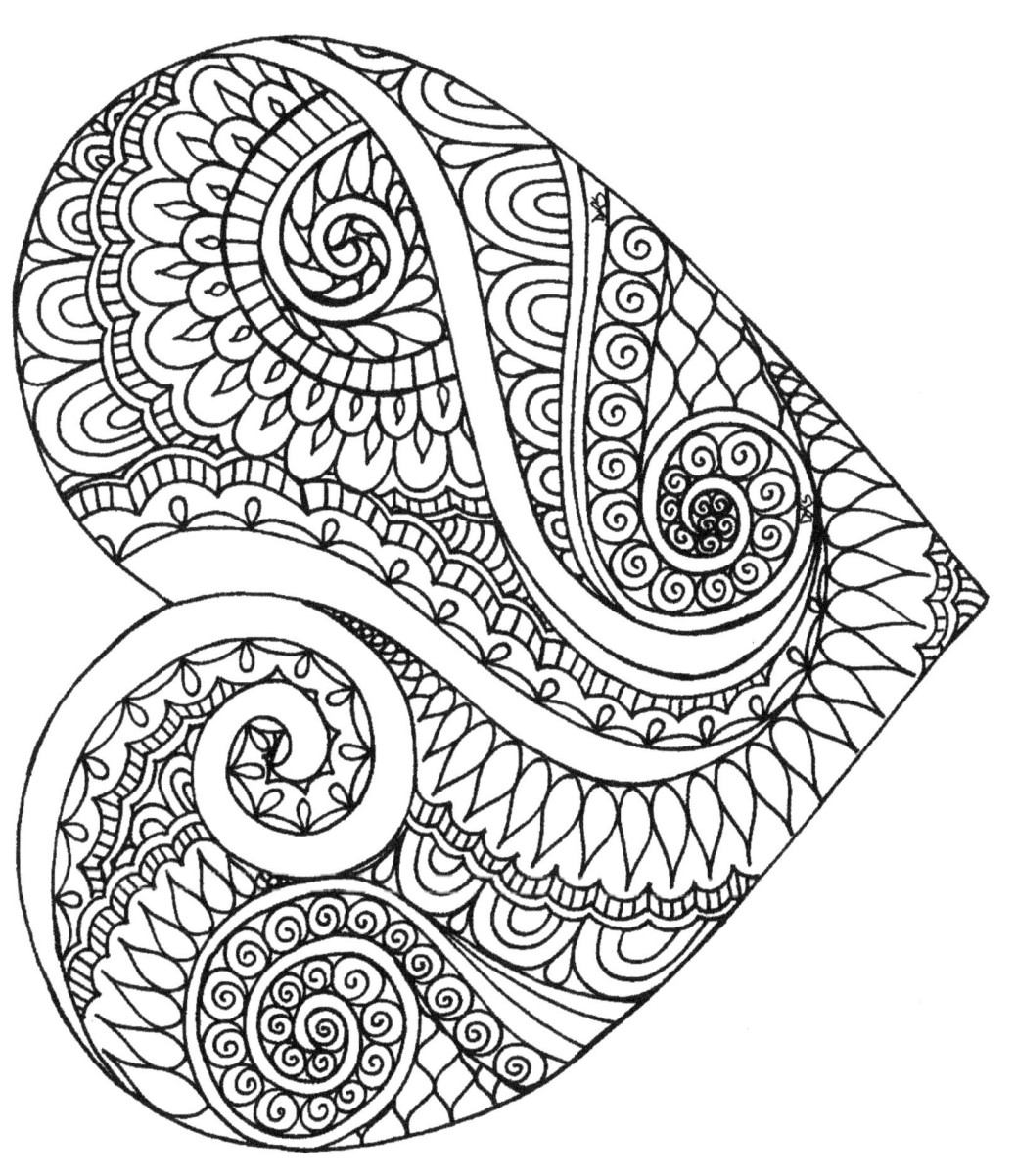

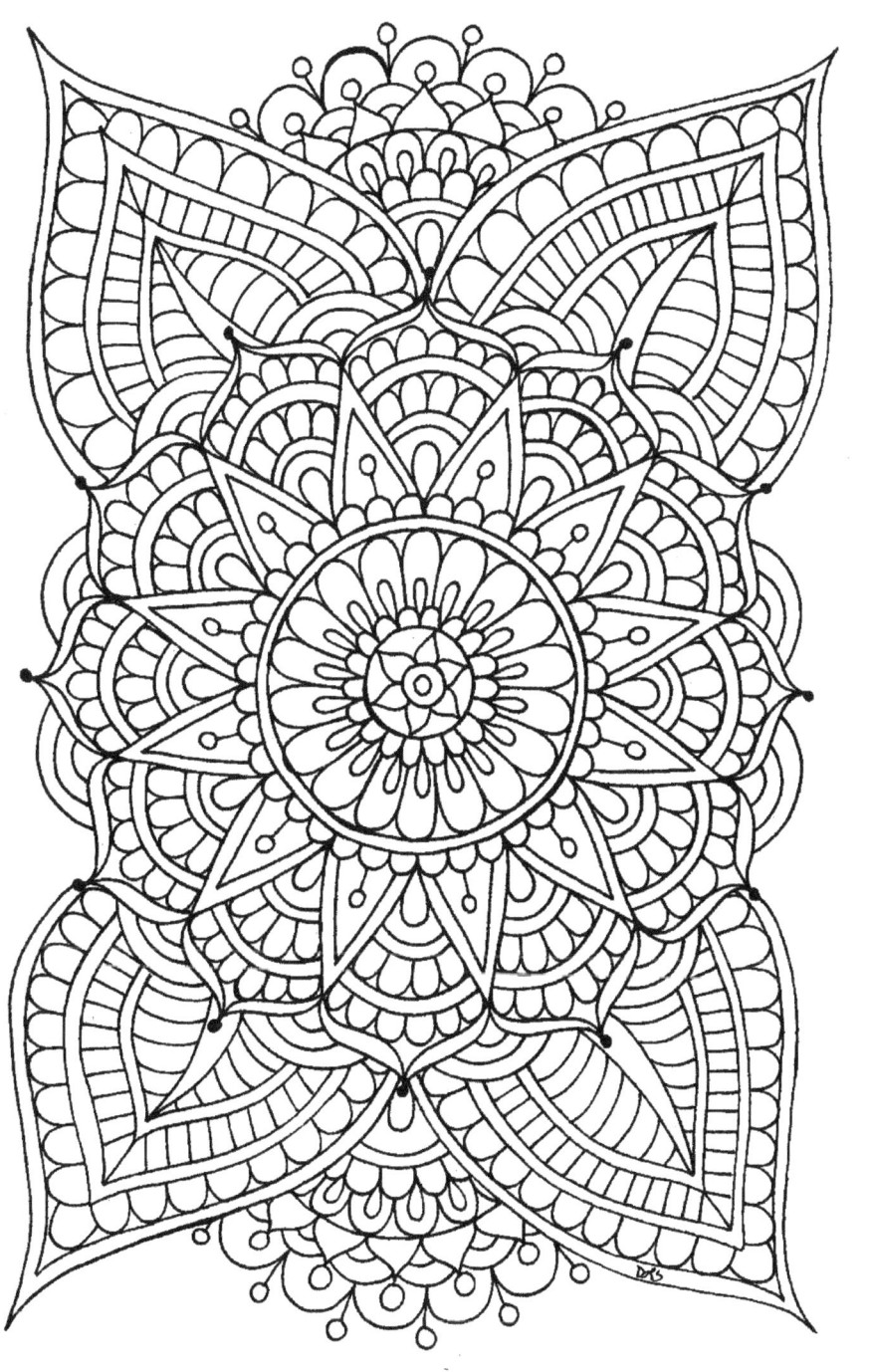

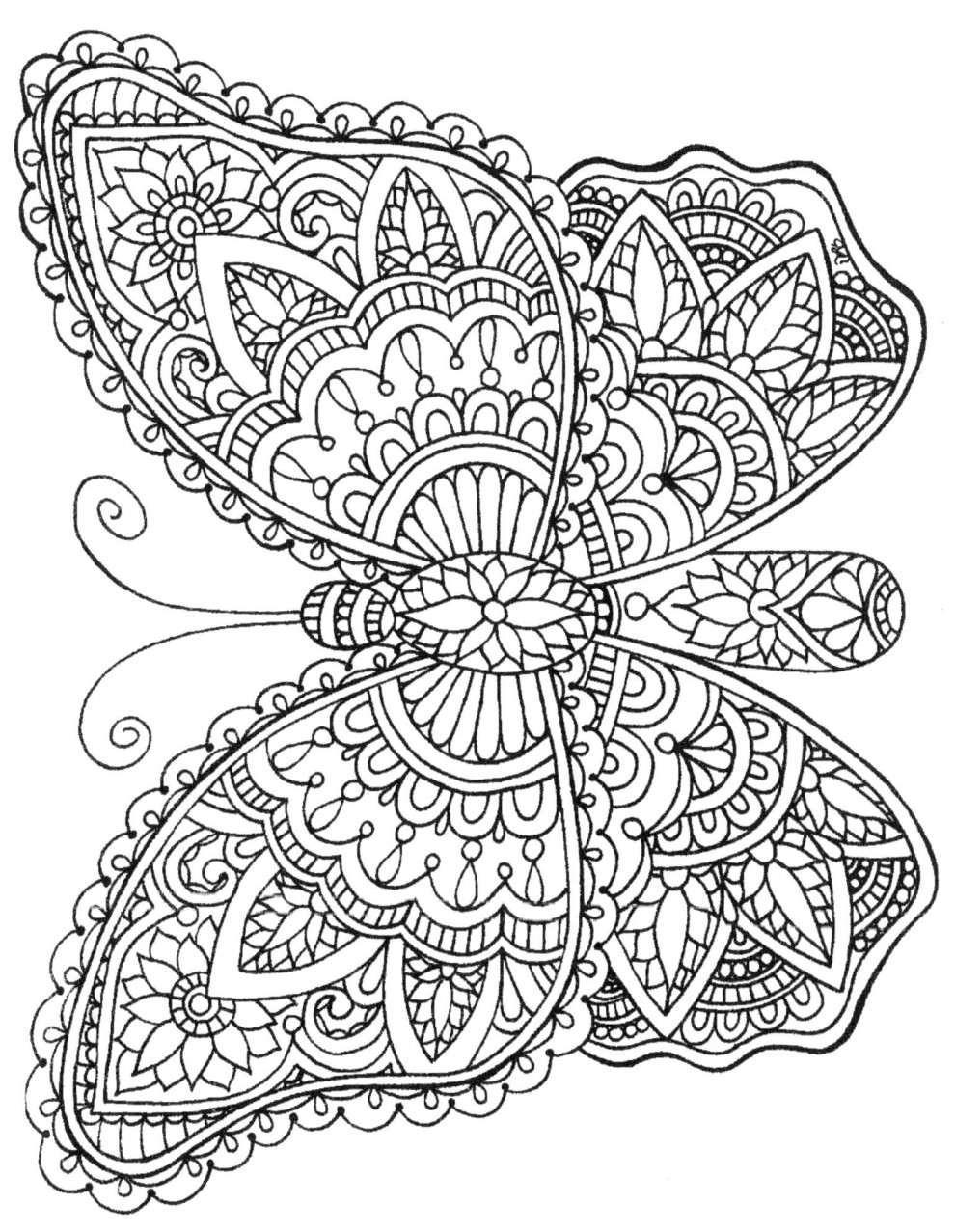

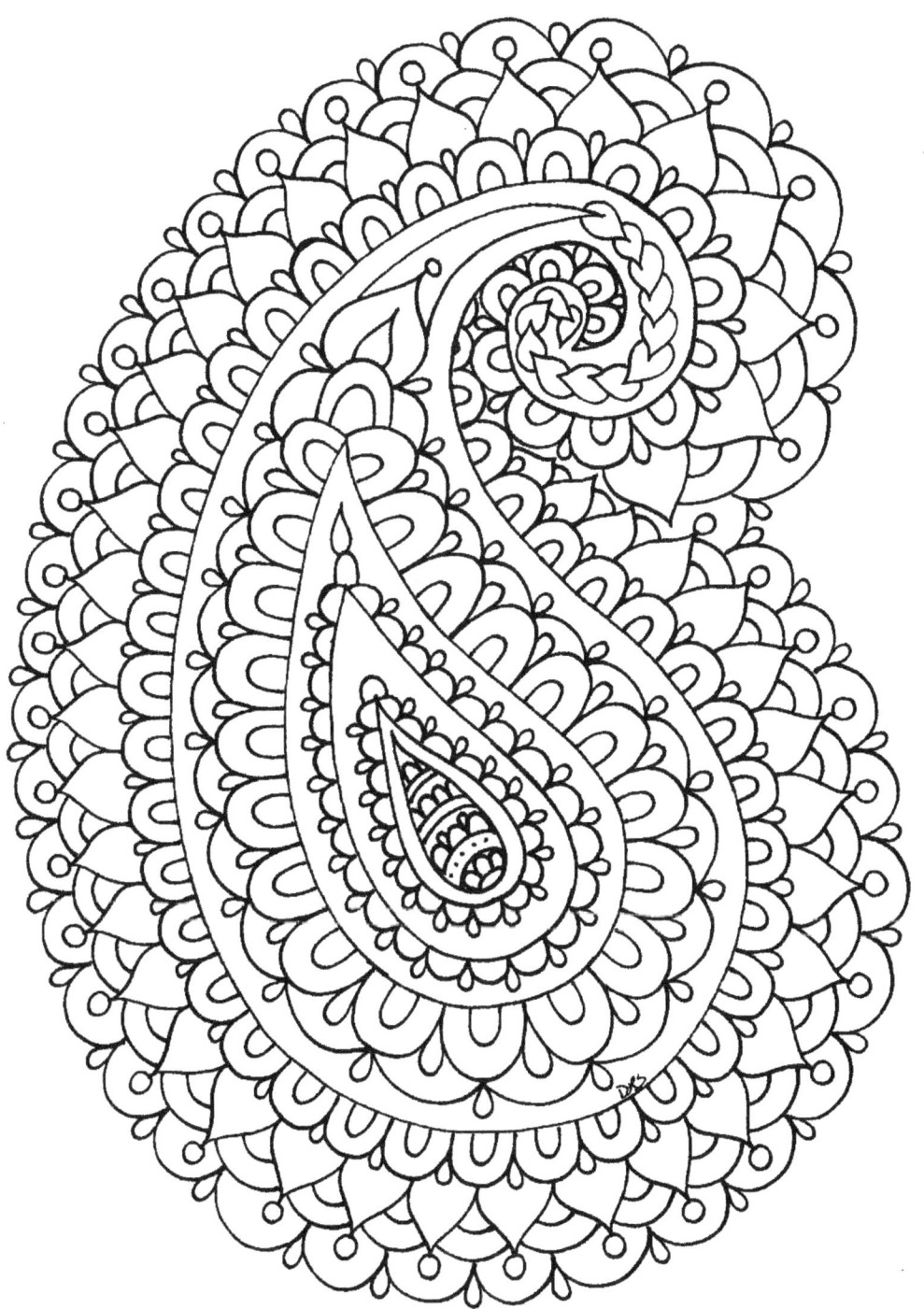

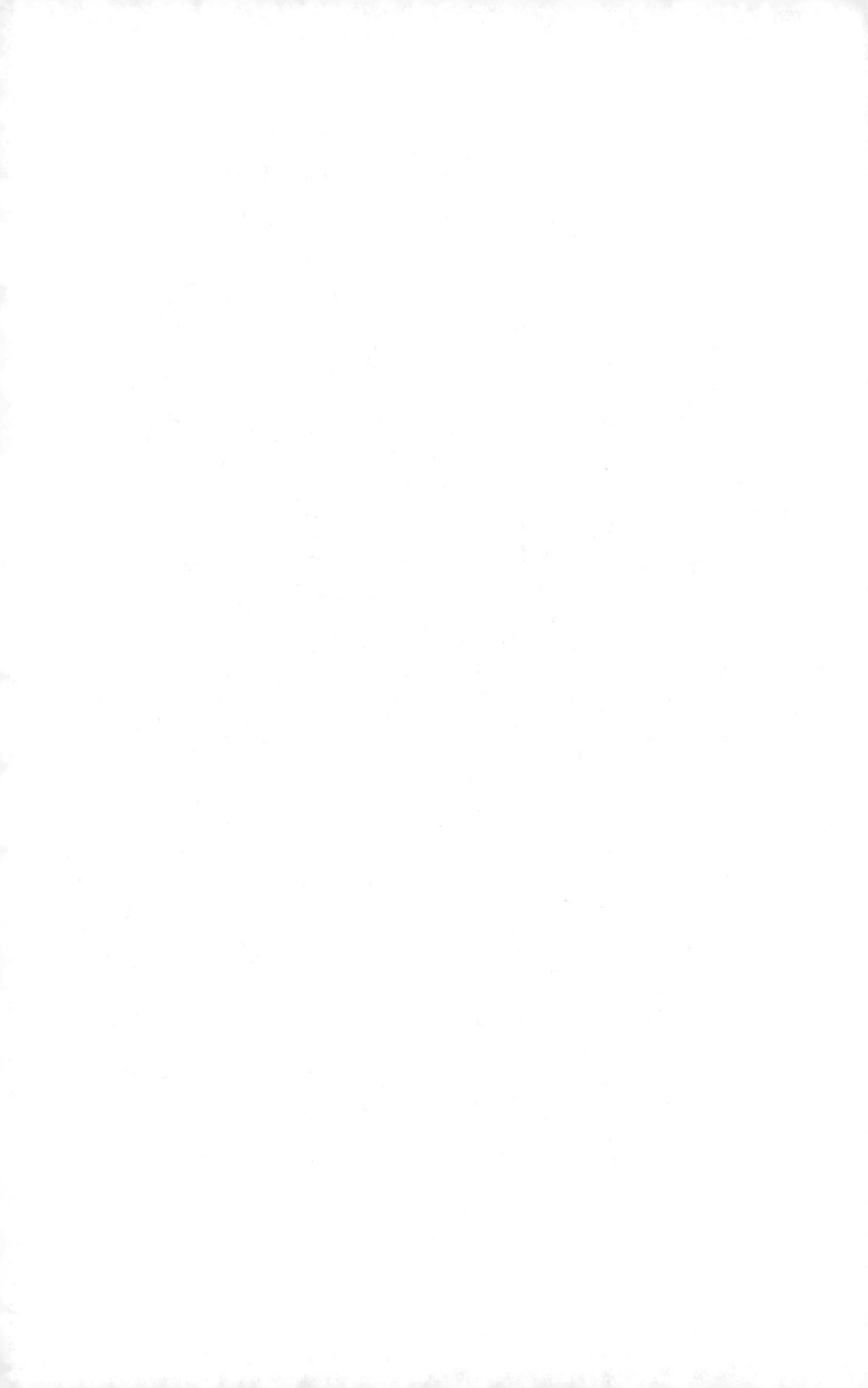

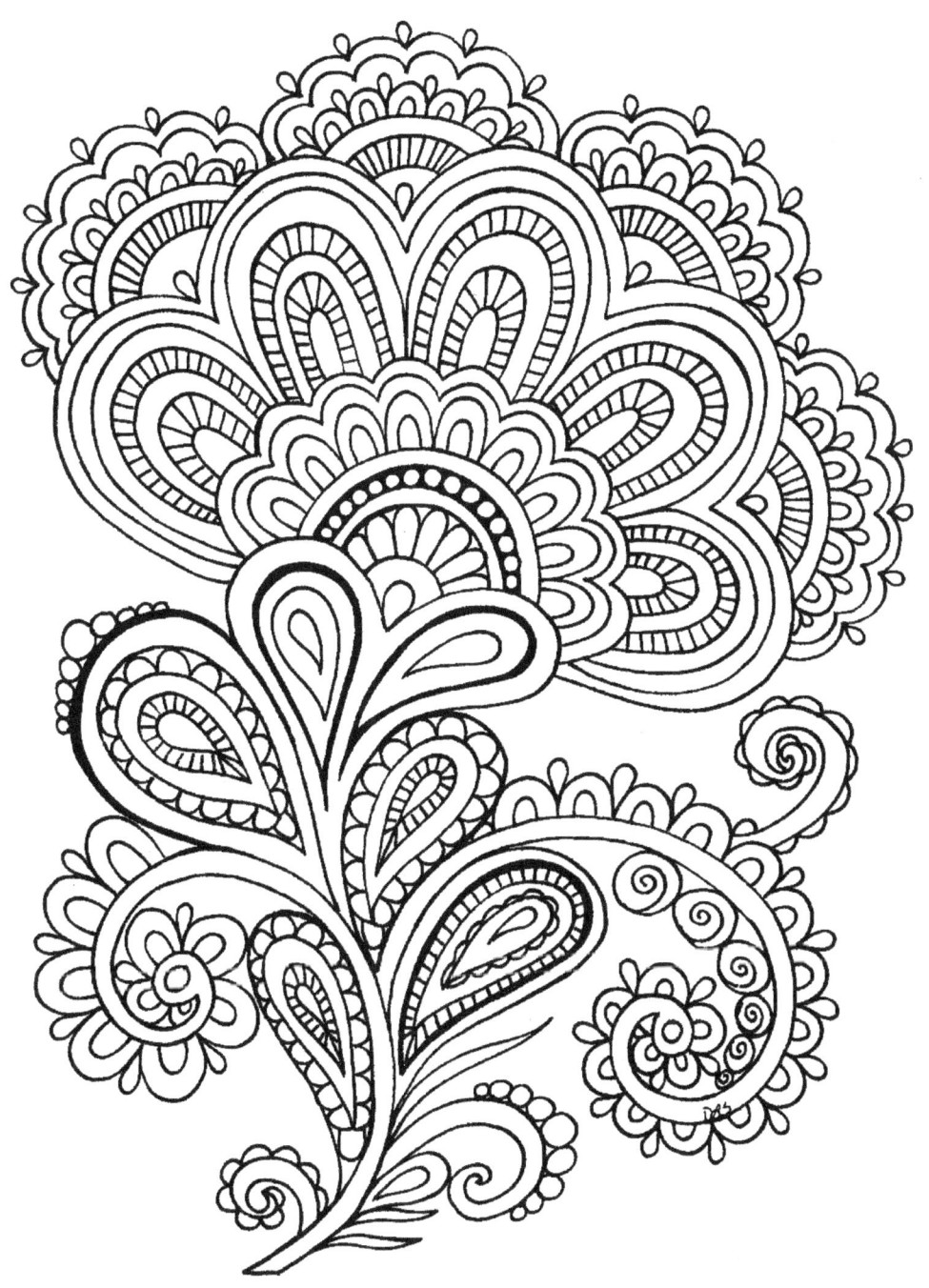

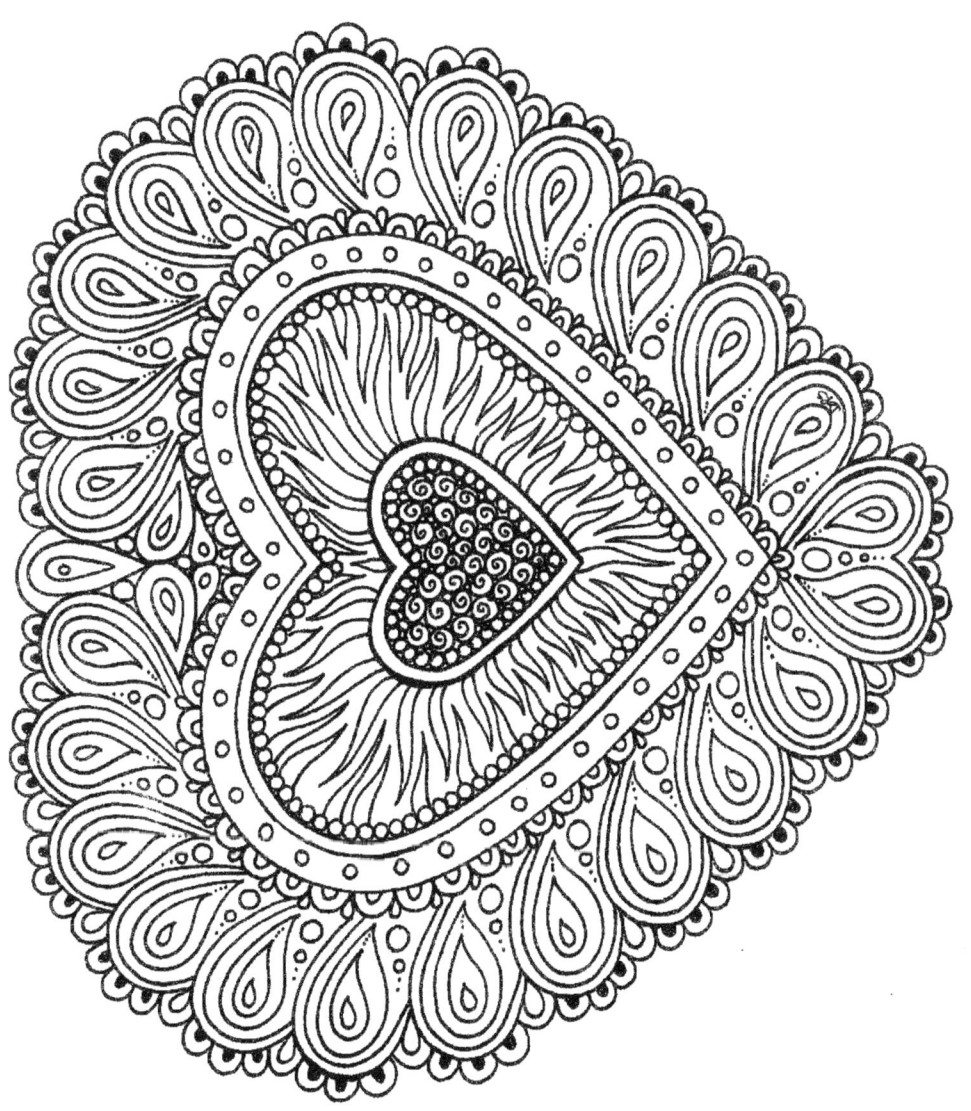

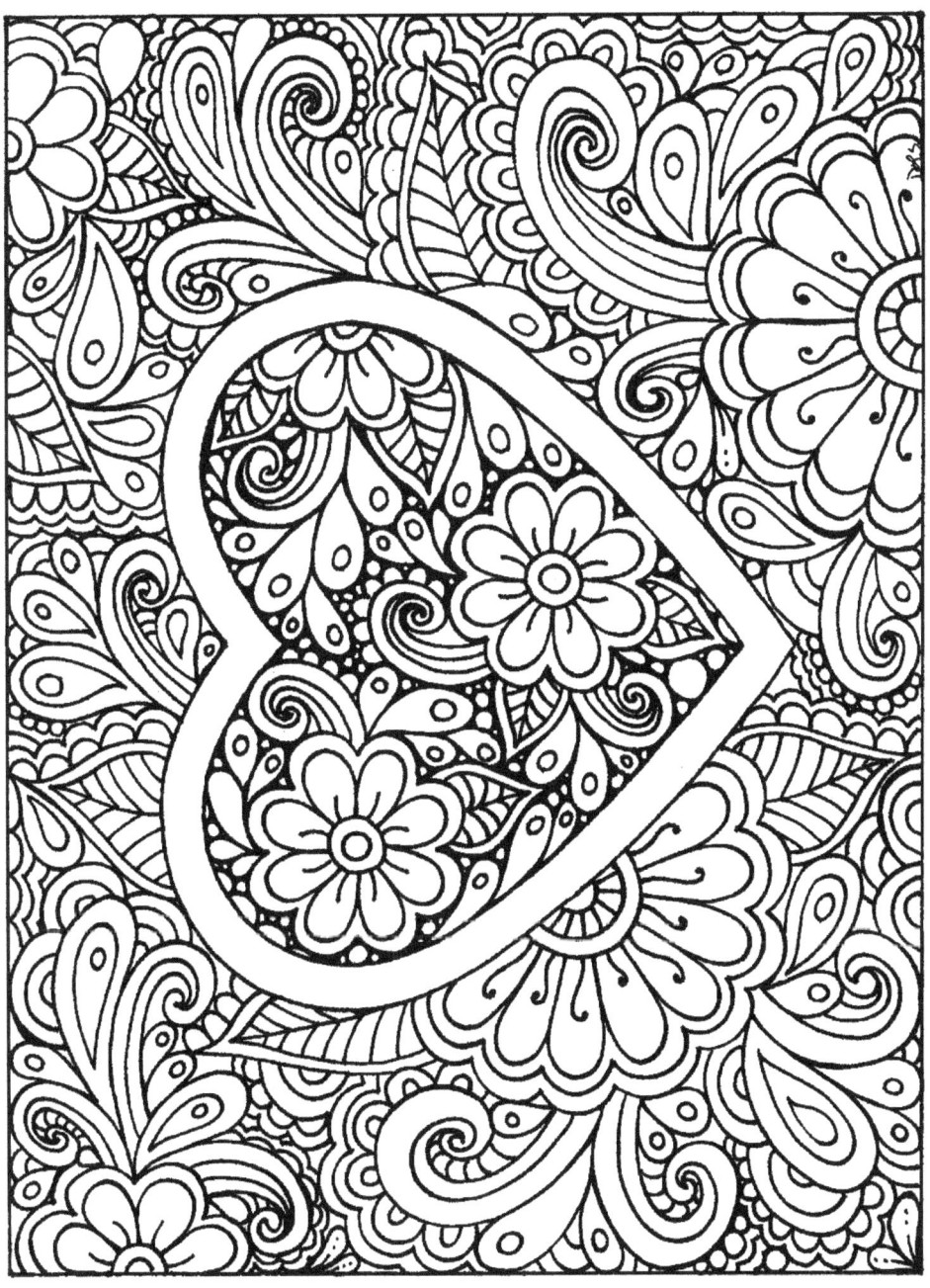

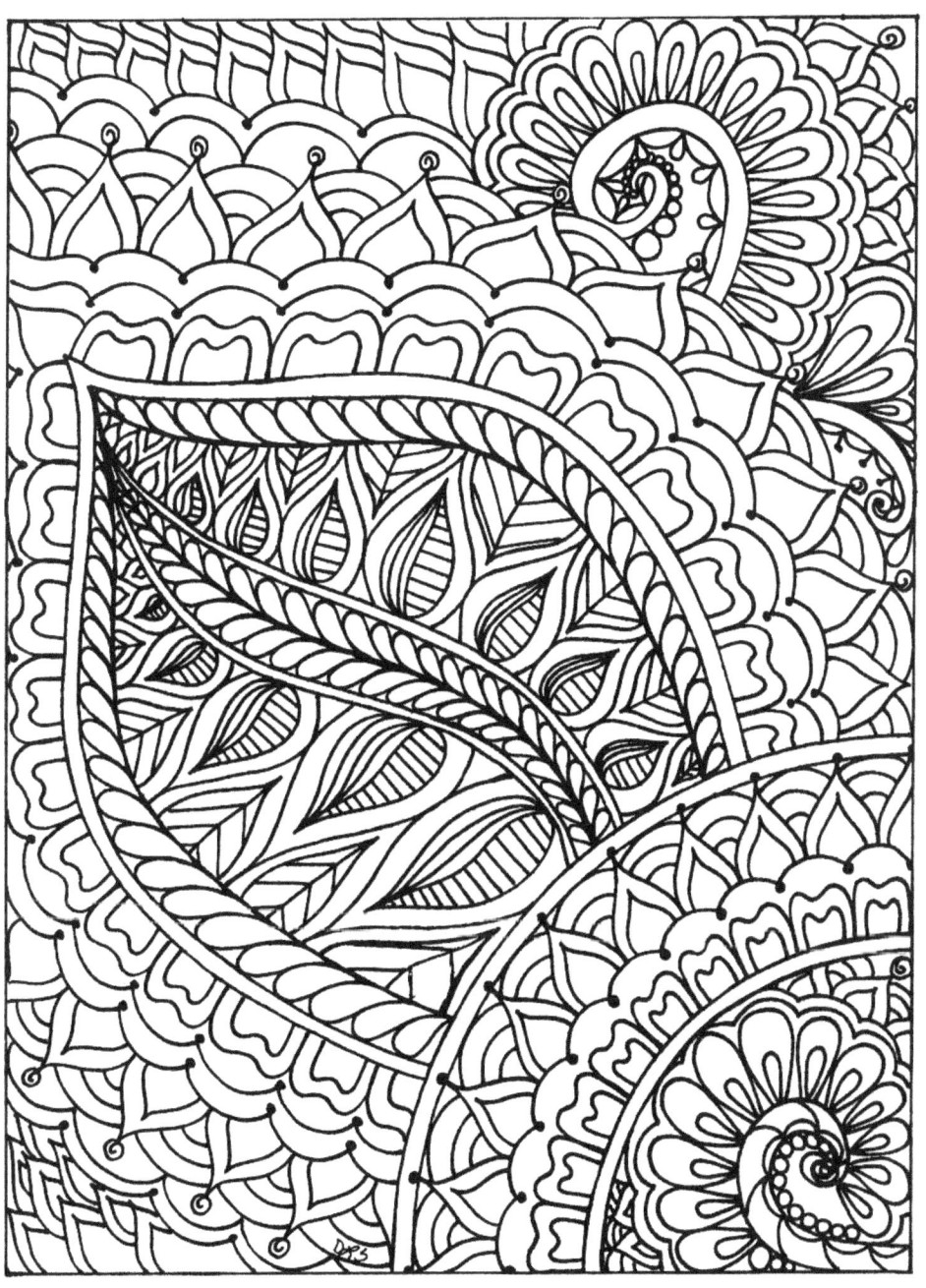

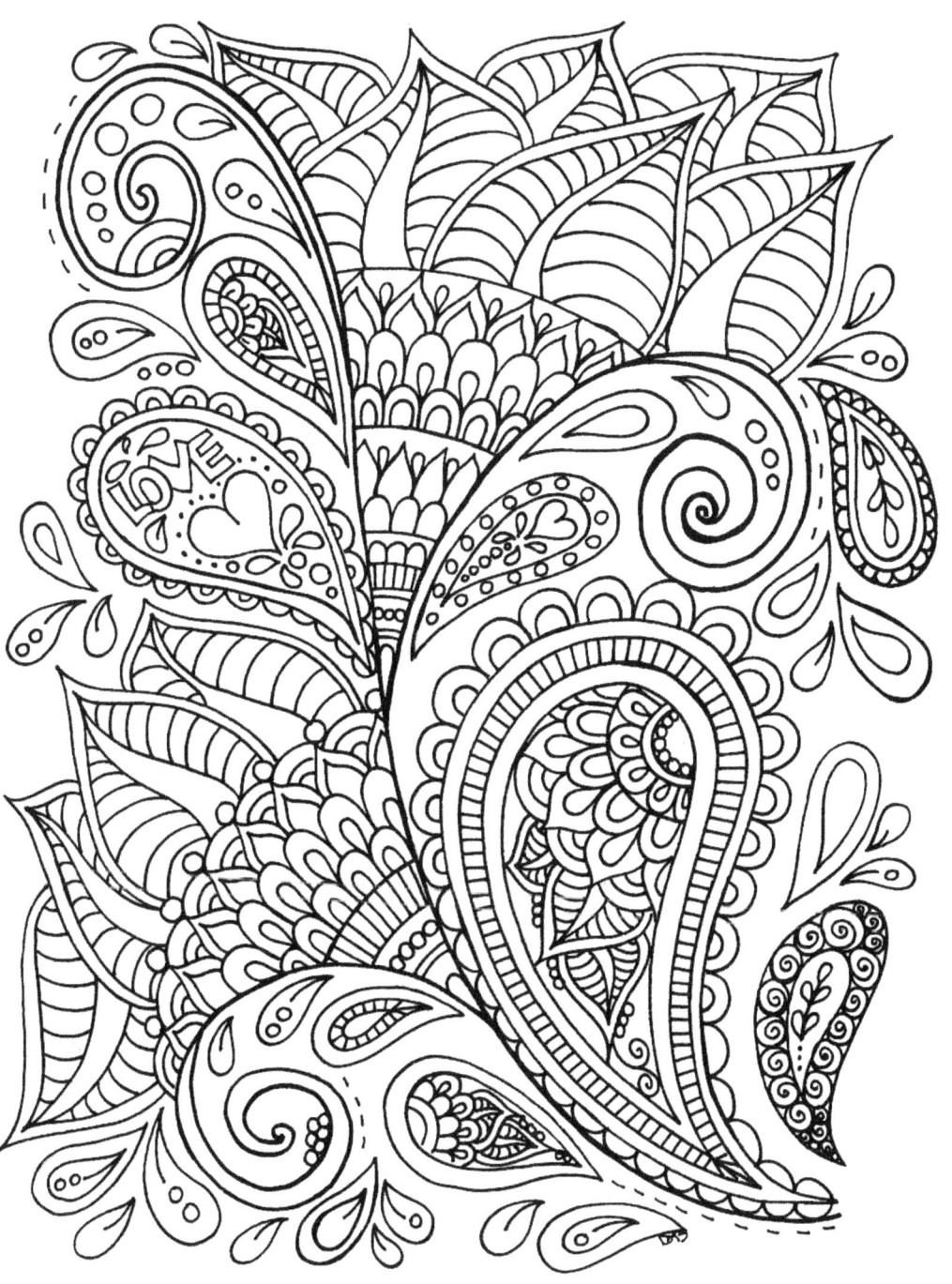

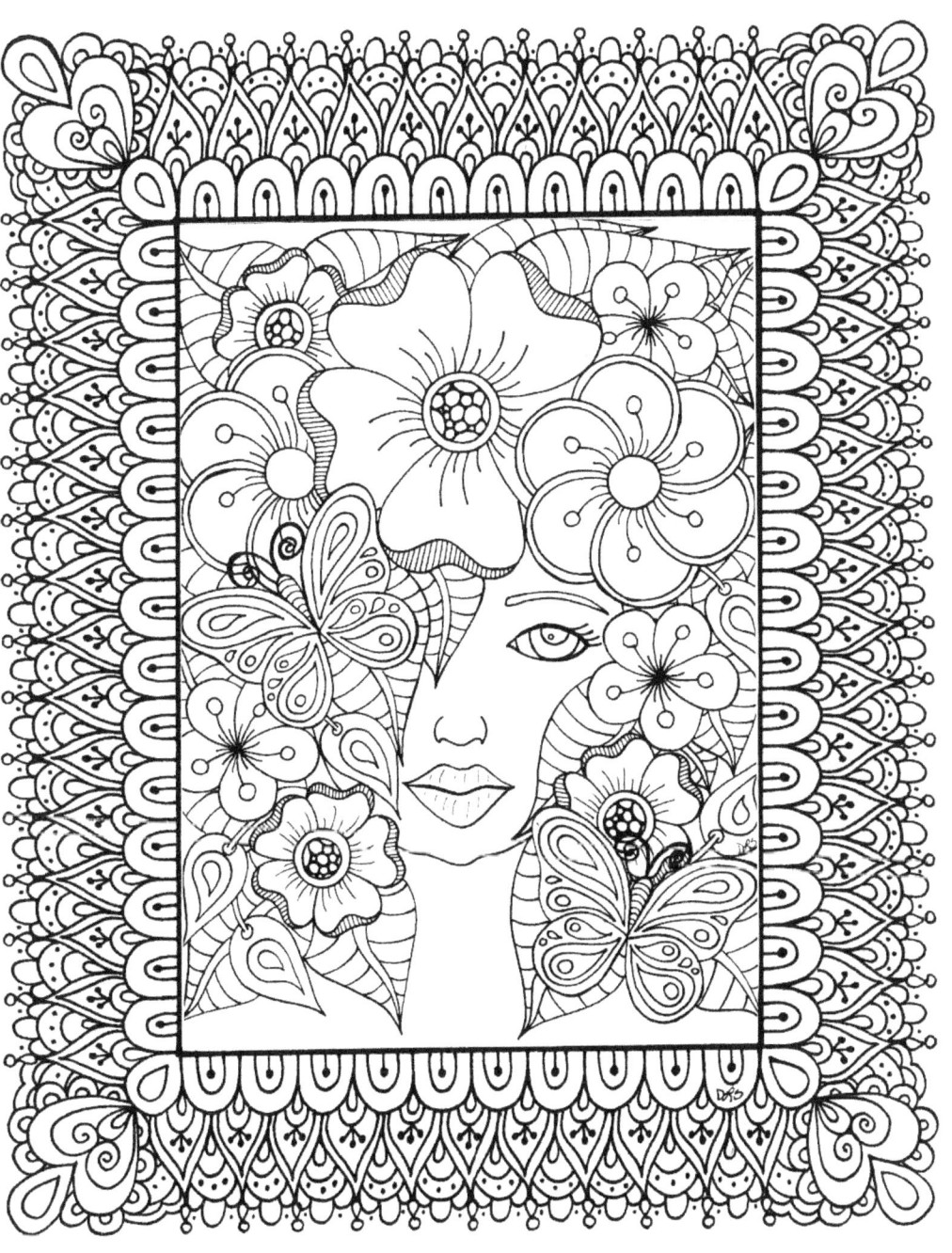

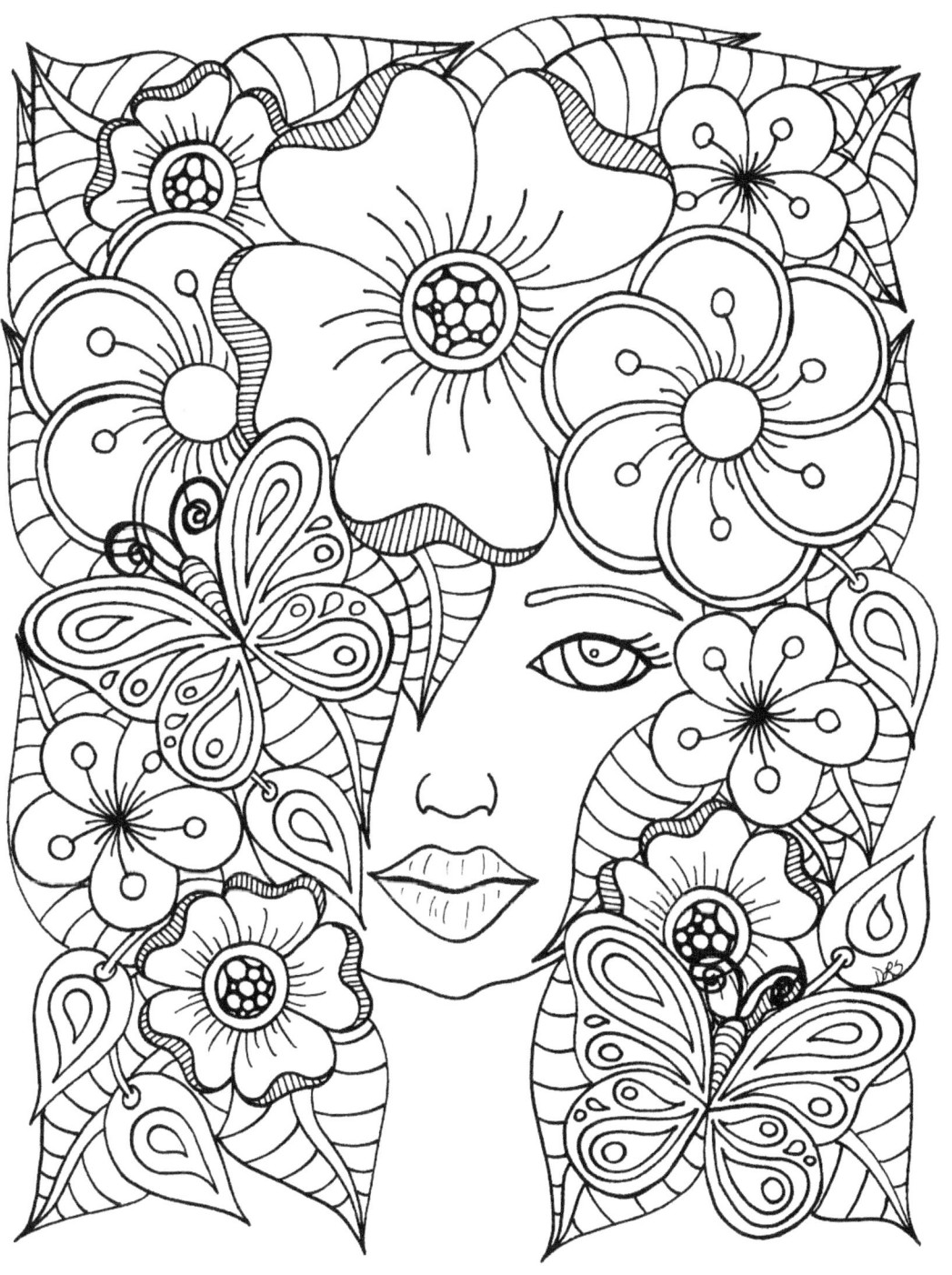

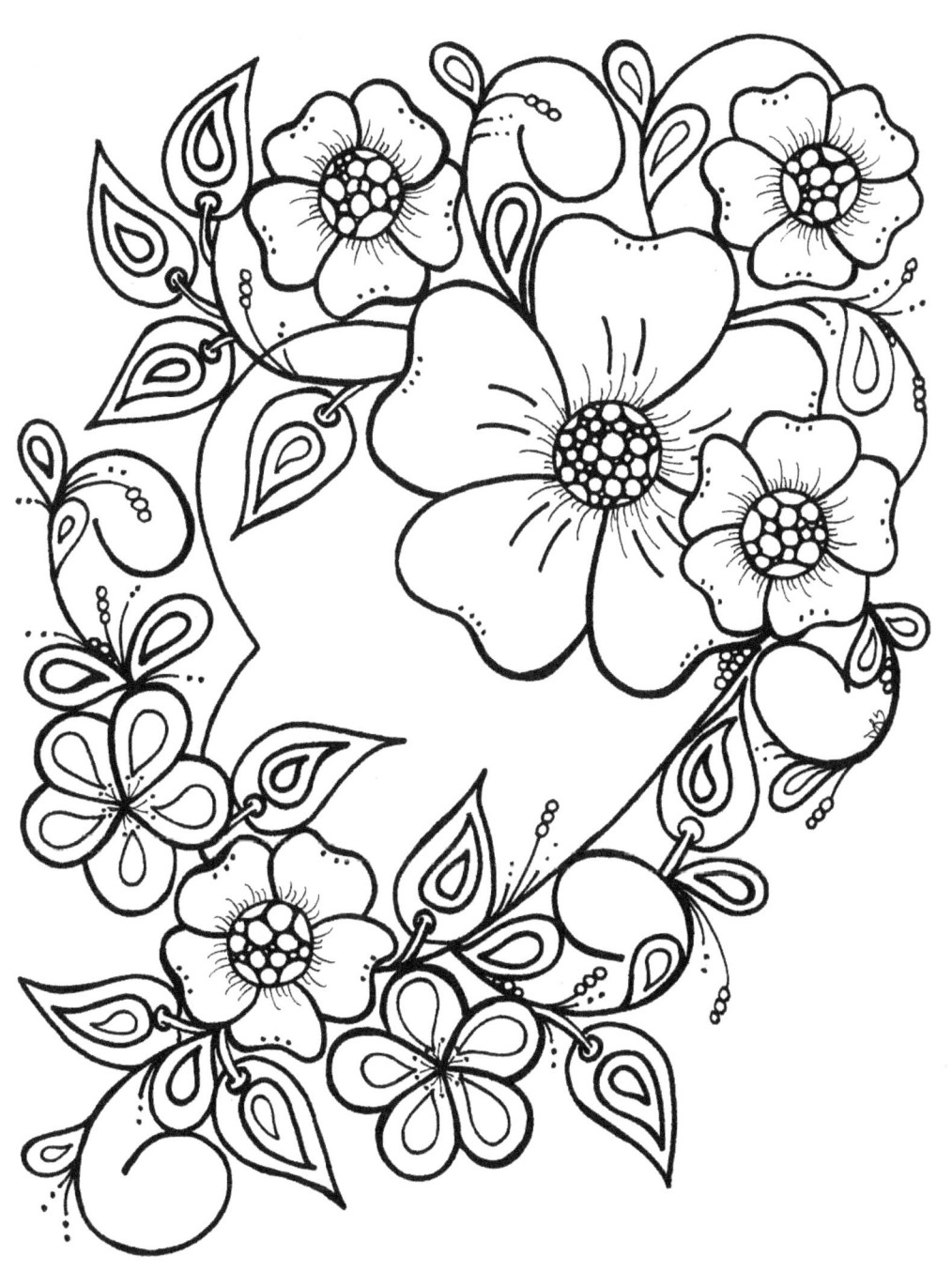

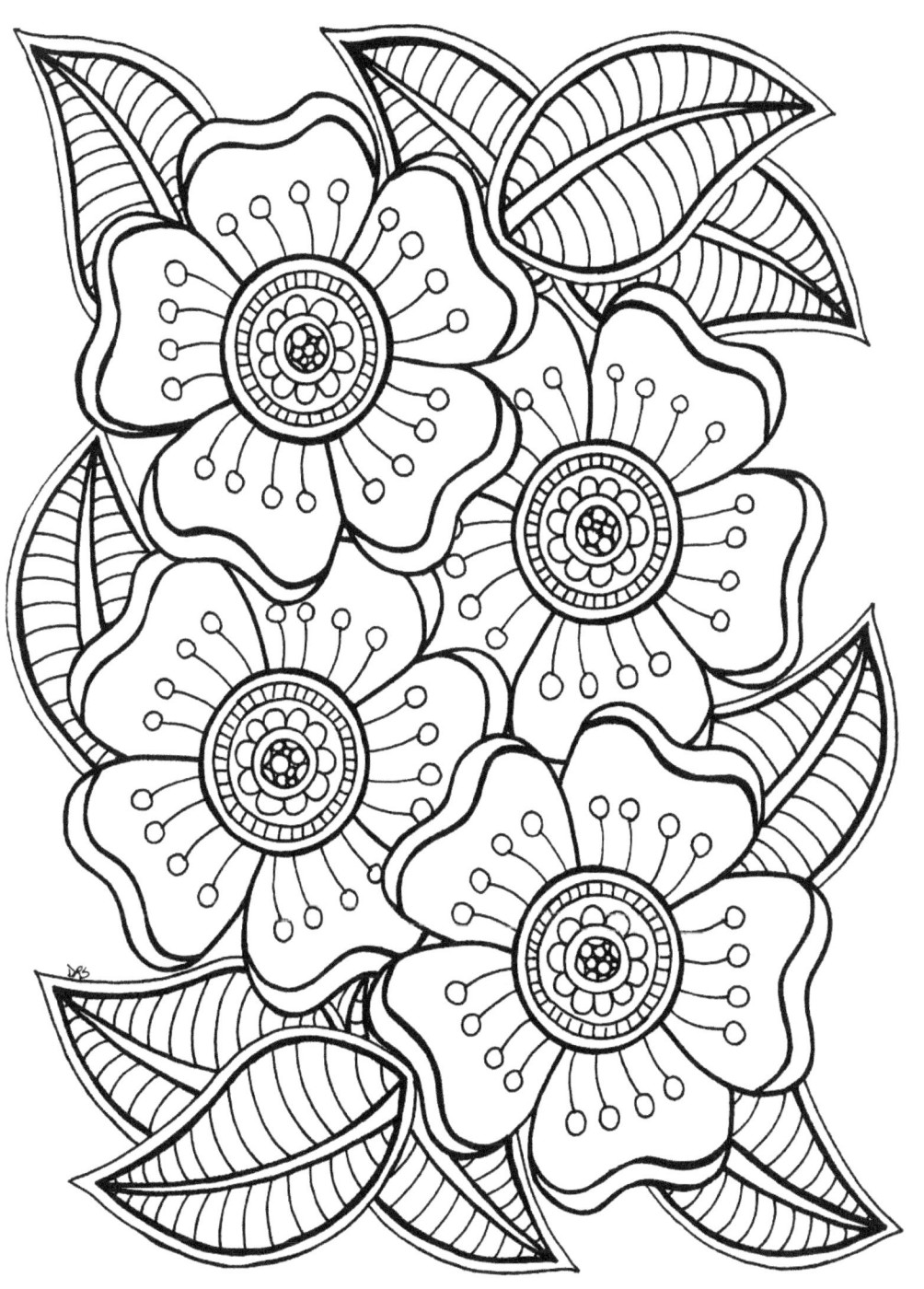

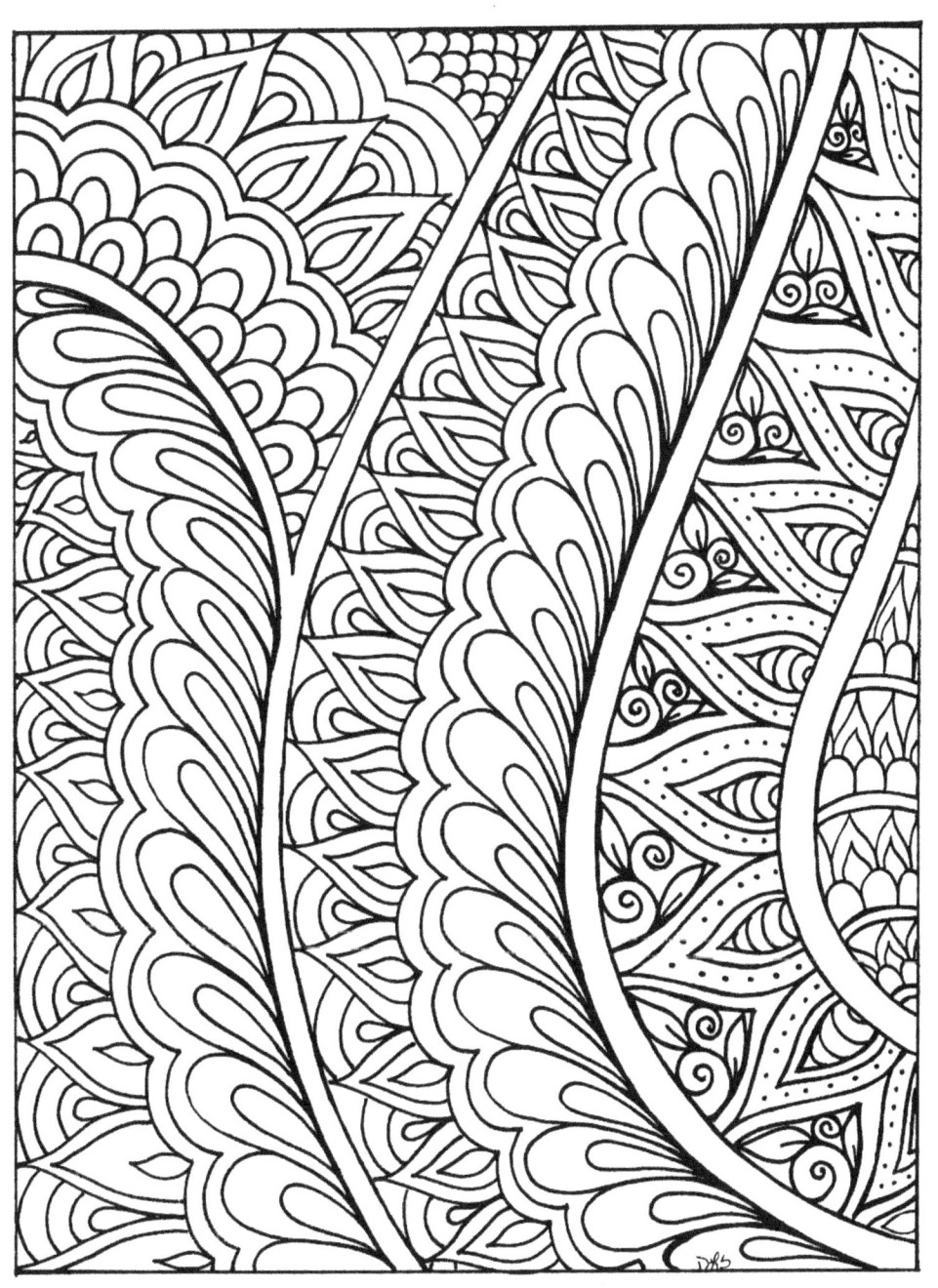

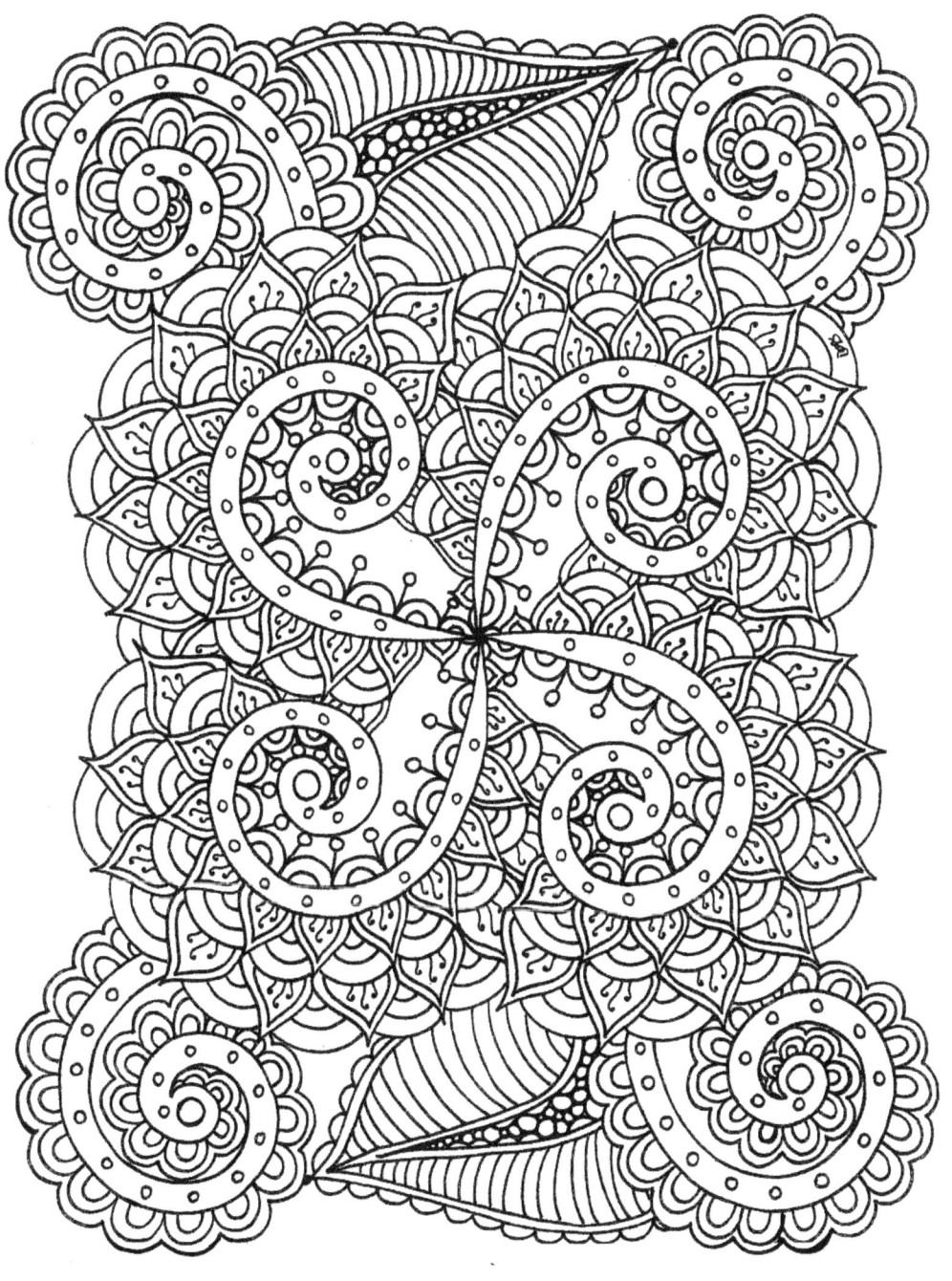

www.ingramcontent.com/pod-product-compliance
Lightning Source LLC
Chambersburg PA
CBHW060412190526
45169CB00002B/864